Antoni Tàpies
in Print

Antoni Tàpies

in Print

Deborah Wye

The Museum of Modern Art, New York

Distributed by Harry N. Abrams, Inc. New York

Published on the occasion of the exhibition "Antoni Tàpies in Print," organized by Deborah Wye, Curator, Department of Prints and Illustrated Books, The Museum of Modern Art, New York, May 6 – August 9, 1992.

The exhibition circulated to the following institutions:

Centro Cultural/Arte Contemporaneo, Mexico City
June 13–August 25, 1991

Long Beach Museum of Art, Long Beach, California
September 22–November 24, 1991

The Meadows Museum
Southern Methodist University, Dallas
January 16–March 1, 1992

The Art Museum
Florida International University, Miami
September 11–October 17, 1992

The Detroit Institute of Arts, Detroit
December 11, 1992–February 10, 1993

Museo de Arte Contemporaneo
Caracas, Venezuela
February–May 1993

The exhibition and accompanying catalog were made possible by generous grants from the Generalitat de Catalunya (autonomous government of Catalonia) and the Institute of North American Studies, Barcelona. Additional support was provided by the National Endowment for the Arts.

Produced by the Department of Publications
The Museum of Modern Art, New York
Osa Brown, Director of Publications

Edited by Susan Weiley
Design and typography by Michael Hentges
Design assistant: Belinda Phillpot
Production by Tim McDonough
Color separations by Reprocolor Llovet, Barcelona
Printed and bound by Ediciones Poligrafa, SA, Barcelona.

Published by
The Museum of Modern Art
11 West 53 Street
New York, New York 10019

Distributed in the United States and Canada
by Harry N. Abrams, Inc., New York,
A Times Mirror Company
Distributed outside the United States and Canada
by Thames and Hudson Ltd., London

Printed in Spain. D.L.: B. 37.347-1991

Original art for covers, endpapers, and text by Antoni Tàpies, 1991

Contents

Acknowledgments

To organize an exhibition of the work of an artist who lives in a foreign country, one must depend on special hospitality on brief visits to accomplish all that is necessary. Antoni Tàpies has been remarkably warm, gracious, and responsive to all my questions and requests. It has been a privilege and a delight to work with him.

At home, I am grateful to my colleagues at The Museum of Modern Art. Riva Castleman, Deputy Director for Curatorial Affairs and Director of the Department of Prints and Illustrated Books, saw the merits of this project when I first proposed it and has been a constant source of support. Andrea Feldman, Curatorial Assistant, has been a model of efficiency, intelligence, and comraderie. Earlier on, Kathleen Slavin, formerly Curatorial Assistant, began the difficult task of interpreting Tàpies's print techniques. Carol Smith also lent her expertise to these technical questions. For research and other responsibilities, several summer interns have been a pleasure to work with: Sylvia Escobar, Nicole Johnson, and Francesca Pfister. The difficult task of typing fell first to AnnaSheila Parrucho, formerly Clerk Typist, and finally to Susan Whitmer, Clerk Typist. I am grateful for their patience and their instructions on word-processing.

Outside my own Department, Janis Ekdahl, Assistant Director of the Library, was tireless in tracking down obscure references in Spanish and Catalan. Hikmet Dogu, formerly Associate Librarian, faciliated a large number of loans from other libraries. Mary Klindt of the Registrar's Office handled arrangements for a complicated group of international loans; Kate Keller, Chief Fine Arts Photographer, and Mali Olatunji, Fine Arts Photographer, overcame the difficulties of photographing books and embossed prints; Robert Stalbow, Frame Shop Supervisor, and John Martin, Lead Matter/Framer, designed special frames; Eleni Cocordas, Associate Coordinator of Exhibitions, organized the tour; and Marina Urbach, of Visitors Serivices, willingly helped with translations in several languages. For the catalog, thanks must go to Susan Weiley, Editor, who helped me say what I wanted to say; to Michael Hentges, Director of Graphic Design, for his sensitive interpretation of what is an artist's book as much as it is a catalog, and to his assistant, Belinda Phillpot; and to Tim McDonough, Production Manager, whose high standards have prevailed.

On behalf of the Board of Trustees of The Museum of Modern Art I would like to thank all the lenders to the exhibition. Many individuals helped facilitate these loans and never seemed too busy to help with our countless questions. Special thanks to the staff of the Fundació Tàpies, Barcelona; Dorothy Cater and the staffs of Galeria Joan Prats, New York, and Polígrafa, Barcelona; Jean Frémon, Mary Sabbatino, and Alix de Courson of Galerie Lelong,

New York and Paris; A. Tàpies-Barba of Edicions T, Barcelona; Carl Hecker of the David Anderson Gallery, Buffalo; Yoyo Maeght and Isabelle Aubard of Galerie Adrien Maeght, Paris; Eduard L. Hilti of Grafos Verlag, Vaduz, Liechtenstein; Franz Larese of Erker, St. Gallen, Switzerland and Hans-Robert Thomas, Weiden, Germany. I would also like to acknowledge that this exhibition and catalog has been made possible by generous grants from the Generalitat de Catalunya (autonomous government of Catalonia) and the Institute of North American Studies, Barcelona. John S. Zvereff, Executive Director of the Institute, deserves our gratitude for his help on behalf of this funding. Additional support was provided by the National Endowment for the Arts.

An exhibition of Spanish art required advice and help from specialists. I would like to thank Dan Cameron, Mary Ann Newman, and William Dyckes, all of New York, for their special insights. In Barcelona, I would like to thank Joan Gaspar of Sala Gaspar; Carles Taché of Galeria Carles Taché; Joan de Muga of Polígrafa, and his printers Eloy Blanco, Salvador Martí, Frederic Soto, and Joan Vidal; as well as the printers Damià Caus; Virgil and Tristan Barbarà; and Joan Roma and Takeshi Motomiya. I would like to thank Jürg Janett of St. Gallen, Switzerland, for his discussions about Erker; and René Lemoigne in Paris for information about lithography.

On a personal level, I would like to thank my sister, Barbara Marcks, for her support, and especially my husband, Paul Brown, and daughter, Becky Brown, who have been so patient with my long hours. Both personally and professionally, I would like to particularly acknowledge the team that works with Antoni Tàpies in Barcelona, without whom this project would have been impossible. Thanks are extended to my friends Sandra Fortó-Fonthier, Registrar, and Manuel J. Borja-Villel, Director of the Museum of the Fundació Tàpies; Miquel Tàpies, Director of the Fundació Tàpies; Margarita Burbano; and the artist's wife, Teresa Tàpies. I dedicate the catalog to this remarkable group.

Lenders to the Exhibition

David Anderson Gallery, Buffalo, New York

Galerie Lelong, New York

Galerie Adrien Maeght, Paris

Galeria Joan Prats, New York

Fundació Antoni Tàpies, Barcelona

Hans-Robert Thomas, Weiden, Germany

Grafos Verlag, Vaduz, Liechtenstein

Private collection, New York

The Language of Antoni Tàpies

Surface and Symbol in Prints and Illustrated Books

"I approach all of my work with the same spirit," responds Antoni Tàpies to a query about his printmaking; the only difference is that a master craftsman is by his side as he develops his relationship with the stone or plate.[1] Tàpies explains that a rich dialogue unfolds with the master printers, and observes that the opportunity to work with others offers him "a larger view." Almost by definition, however, printmaking offers other differences, in particular the physical surroundings of the print workshop rather than the artist's studio, and the world of unfamiliar materials and processes. However, neither ink and paper, nor plates, stones, or printing presses inhibit Tàpies. His ideas invariably present technical challenges to his printers. Meeting them is an adventure, as evidenced by the excitement of both artist and printers as they recount innovative processes that led to an oeuvre of over one thousand printed works. Although they possess unique characteristics, these works are best viewed in the context of Tàpies's long career as an artist involved with painting, assemblage, and sculpture.

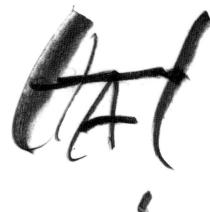

Tàpies, Spain, and the International Art World

When those with an interest in the visual arts think about Spain in the modern period, the names of Pablo Picasso, Joan Miró, and Salvador Dali come to mind, followed in quick succession by thoughts of Franco, the Spanish Civil War, and Picasso's *Guernica*. Recently contemporary Spain has gained attention: it has a place in the European community and in the international art world, and it boasts new modern art museums, a successful art fair, and a roster of celebrity artists. The life and work of Antoni Tàpies interconnect with all of these phenomena. His finely tuned responsiveness has put him in constant dialogue with the art and society surrounding him, and this exchange is fundamental to his work.

Born in 1923 in Barcelona, Tàpies was a teenager while the Spanish Civil War raged in 1936–39. Catalonia, the area of Spain of which Barcelona is the capital, was among the final strongholds of resistance to Franco's troops. After the war Franco was quick to thwart any potential resistance there by forbidding that proud culture's very foundation: the Catalan language. Tàpies's family had strong cultural and political links to Barcelona and its Catalan culture. His upbringing was comfortably bourgeois, as well as liberal and intellectual. Book-publishing and bookselling had long been professions of his mother's family; and his father, a lawyer, wrote novels, although unpublished.

Tàpies displayed artistic talent as a youth but was urged by his family to follow his father into the legal profession. While studying law, the young Tàpies continued his painting and drawing. In the early 1940s, however, he suffered from a serious lung infection and was required to convalesce for almost two years. This period, which provided time for drawing, music, and reading, as well as deep reflection, would prove life-altering. During certain episodes he felt close to madness, experiencing almost mystical revelations that he believes reflected deeply personal intuitions. Such revelations call to mind the hallucinatory episodes of the Surrealists, who sought levels of reality that were more authentic than those available in

9

the natural world. And it was Surrealism, with its exploration of the subconscious, that provided the foundation of Tàpies's thinking during the formative years after he had abandoned his law studies in 1946 and turned definitively to art.

In Barcelona in the late 1940s there was a small group of artists and other intellectuals who reacted against the conservative atmosphere of the cultural life of the city and hoped to continue the avant-garde explorations that had preceded the war. This group was encouraged by the presence of Joan Prats (1891–1970), a commercial hat-maker, who as a collector and patron of the arts played an important role in avant-garde circles. Tàpies pays homage to him in a lithograph of 1975 (pl. 36). It was Prats who introduced Tàpies to the paintings of Miró in his private collection and finally, in 1948, to Miró himself.

Joan Brossa (b. 1919), the Catalan Surrealist poet and dramatist of Tàpies's generation, was the inspiration of the painters and literary figures who in 1948 founded *Dau al set*, an underground journal of art and poetry. His sophistication and adventurous spirit would prove extremely invigorating for Tàpies in his early artistic career, and the two men created a dialogue that has lasted throughout their lives. During a time in the late 1940s and early 1950s, Brossa even gave titles to Tàpies's work, a common practice with Surrealist poets and painters.

Frustrated by Spain's political and intellectual isolation, and hoping to find a serious dealer for his work, Tàpies went to Paris on a ten-month scholarship in 1950–51. He met Picasso and in general was greatly stimulated, but his efforts to find a dealer led only to disappointment. He returned to Barcelona and to what, after a relatively brief period of struggle, would be a decade in which he defined himself artistically and met with increasing success.

From his involvement with Surrealism Tàpies evolved a deeply Romantic view of art, believing in its transformative nature and thus its importance in the world. He has said, "The basic questions, the whole new vision of the world which stimulated me, were things that I . . .

experienced very intensely during the 1940s and early 1950s, when the desperate situations of the terrible postwar years made us profoundly sensitive to the great themes of existence and social co-existence."[2] The process of Surrealist automatism, in which an artist allows spontaneous gesture to be the carrier for unconscious thoughts and feelings, became fundamental to his creative process. "I have to enter into a sort of trance that will give me the feeling that my work is being guided by a cosmic force,"[3] he has said. "In the end, the work itself takes over, and you don't even know you're working."[4] Tàpies incorporated this intuitive method in the 1950s, when he experimented with novel materials for his paintings. He combined marble dust, sand, pigment, varnish, and latex to create thick, rough, gray surfaces that resembled cement. These works were hanging objects more than painted canvases. They displayed scars suggesting fossils, and cracks and fissures that seemed to be an organic effect of an elemental process. Tàpies's "Matter Paintings," as they were called, seemed impervious and confrontational.[5]

Matter Painting, derived from automatism, was one manifestation of an art of spontaneous abstraction that was widespread in the 1950s. Under such various labels as "Informel," "Tachisme," "Art Autre," and in Japan, "Gutai," these styles parallelled Abstract Expressionism in America and constituted an international phenomenon. Stressing the individual exploration of the unconscious, which was "acted out" with paint on canvas, this work was linked to the philosophy of Existentialism, wherein responsibility for action resided with the individual. In France Jean Dubuffet and Jean Fautrier worked with dense surfaces comparable to those of Tàpies. Other artists were also often exhibited with him, including the Paris-based Wols, Henri Michaux, Georges Mathieu, and Jean-Paul Riopelle; the Italians Alberto Burri, Giuseppe Santomaso, Lucio Fontana, Enrico Donati, and Emilio Vedova; the Germans Emil Schumacher and K. F. Dahmen; and Cobra artists Asger Jorn, Karel Appel, and Pierre Alechinsky.

11

Spanish artists working in the Informel style (the most widely used European term for this phenomenon) included painters Antonio Saura and Manolo Millares and sculptor Eduardo Chillida, along with Tàpies. But their version of the style was interpreted as being distinctly Spanish, with a Romantic undercurrent that called to mind visionary aspects of Catholic mysticism, the somber color and parched dryness of the Spanish landscape, a preoccupation with death manifested in the blood and violence of bullfights, the tragedy of civil war, and the resulting despair of political oppression and intellectual isolation.[6]

Spanish Informel, which received more attention outside Spain than any other movement in the Franco era, is now perceived as having been used for the government's political agenda.[7] Since abstract art was unfathomable to most and therefore harmless in terms of offering dissenting content, the Fascist government is thought to have exported paintings in this style to foster the idea that Spain encouraged avant-garde exploration. In fact, the avant-garde was ignored in Spain; in some cases reviews of Informel art were printed only in the international editions of newspapers, but not in the national editions. (Coincidentally, some historians have interpreted the export of American Abstract Expressionism during the Cold War as also serving political ends.)

The abstract style that appeared to be the most vital international movement of the 1950s had by the end of the decade become formulaic and cliché-ridden. The energy of authentic spontaneity became stylized lyricism, as the original Existential impulses, based on the expression of the individual act in an alienating world, were lost. Tàpies's work, however, retained its vigor through the introduction of new themes, materials, and compositional structures. Its meaning, reflecting his evolving world view, was enlarged by the development of a vocabulary of images that was tied to both the everyday world and the spiritual realms.

Reactions against the academization of the predominant abstract style were widespread, and Tàpies's work of the 1960s should be considered in their context. One new

approach was to focus on tangible reality rather than on the unconscious. Tàpies's work gave new attention to a human presence and included clear references to the world of everyday objects, both of which contrasted vividly with the relatively barren, gray, textured surfaces of his earlier paintings. Comparable approaches could be found in the work of artists of other countries in the late 1950s and early 1960s. In the United States there was assemblage and neo-Dada, which utilized common materials and imagery. The early work of Robert Rauschenberg and Jim Dine, for example, bears some resemblance to Tàpies's aestheticized treatment of mundane objects. In contrast, the thrust of mature Pop Art would diverge from the interests of Tàpies and focus instead on commercialism itself. In France artists such as Daniel Spoerri and Yves Klein of the Nouveau Réalisme group were similarly concerned with incorporating the everyday world and the human figure into their work, yet with different emphases. Later, in Vienna, Arnulf Rainer imposed the human figure on an abstract vocabulary, and in Germany Georg Baselitz reinterpreted the figure in a new expressionist idiom. By the late 1960s and early 1970s Arte Povera artists in Italy were employing "poor" materials in a variation of the language investigated by Tàpies, who incorporated straw, string, wire, gauze, and burlap.

Disillusionment with the Informel style was also apparent in other Spanish art.[8] One new direction, taken by Equipo 57, involved works based on principles of geometry and harmony that might influence the human environment. Another involved figuration with elements of Pop Art and mass-media conventions. The collaborative Equipo Crónica appropriated concepts from earlier Spanish art and wove them together with references to commercial culture and politics. By the late 1960s and early 1970s political protest intensified in Spain, as it did internationally. Vigorous dissent was leveled at Franco's government, particularly since it had been reasserting its power with new abuses at a time when its end was clearly in sight. Tàpies himself was arrested in 1966 after participating in a clandestine meeting of students and intel-

lectuals that supported the formation of a democratic students' union for the University of Barcelona. His work of the early 1970s displays an outpouring of imagery related to his native Catalonia, the country and culture that Franco had repressed for forty years.

By this time Tàpies had achieved considerable stature. His participation in important solo shows and group shows, as well as his numerous international honors, made him both a source of pride for his countrymen and a foil against which to react. In particular, artists of the Conceptual movement, situated primarily in Barcelona, criticized Tàpies's work for being a commodity in what they considered a corrupt market, and for its references to the spiritual and transcendent, which they considered outmoded. Tàpies, in turn, wrote negative appraisals of Conceptual art for its lack of any visual component, and an acrimonious debate ensued in the press.[9] The central events in Spain in the 1970s, however, occurred outside the art world: the death of Franco in 1975 and the democratic elections held in 1977, the first since 1936.

By the early 1980s young Spanish painters were gaining recognition as part of an international movement of neo-Expressionism.[10] These developments in an emerging democratic Spain coincided with a renewed interest in European art emanating from New York, the major art center since the advent of Abstract Expressionism. Painting was the focus of this new attention, and therefore Tàpies's work remained highly visible. Even as art trends of the 1980s moved toward neo-Conceptualism, his work continued to have relevance as the work of an elder statesman. His development continued unabated: he began emphasizing calligraphy, which underscored his long-standing interest in Eastern culture; he focused new attention on varnish as a material with fluidity, translucence, and the potential to suggest purity and spirituality; and he referred more openly to sexuality, mysticism and death. Sculptural work in terra cotta and bronze reflected his attachment to an ensemble of ordinary objects as subjects.

While the Spanish art world grew in breadth and complexity after the death of Franco, artistic activity had never completely stopped during his regime. Despite the repressive

Fascist government, an art community had continued to exist, on however small a scale: artists worked in styles that reflected international trends, critics continued to write, publishers issued books, and galleries and art magazines contributed to a modest cultural complex. This is the milieu in which Tàpies developed artistically.

In 1990 over four decades of Tàpies's achievements were capped with the opening of the Fundació Antoni Tàpies in Barcelona, in a landmark building designed by Domènech i Montaner (1850–1923), a contemporary of Antoni Gaudí. The Fundació exhibits the artist's work, provides space for major exhibitions by other artists and movements, and offers a program of lectures, publications, and symposia, all fulfilling Tàpies purpose for it: "to educate people to see the message of contemporary art more clearly."[11]

Tàpies and Printmaking

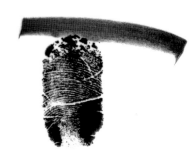

Tàpies's printed oeuvre has a character and development that parallels that of his painting and sculpture, with the fundamental aesthetic approach remaining the same. Yet printmaking's components—including the effects of ink, paper, and the pressure of the press; the special qualities of line and surface possible with numerous techniques; and, usually, smaller scale—all influence expression and meaning. Novel techniques and materials especially appeal to Tàpies, who says, "I'm always experimenting with new ideas and techniques. I'm always trying to surprise myself."[12] The collaborative process itself, involving the publisher and then the printer, contributes additional voices to printmaking with varying results, depending on the personalities involved. Multiplicity, a traditional domain of printmaking, is also used to advantage by Tàpies, who contributes prints for special causes, and designs posters, book covers, invitations and announcements—all of which are distributed more widely than the limited-edition print or illustrated book.

Contemporary printmaking usually reflects developments elsewhere in contemporary

15

art, although with different emphases, depending on styles that are particularly amenable to printed art and to opportunities arising from the network of a market system. In the late 1950s, when Tàpies began making prints in earnest, the primary locus of printmaking was Paris, where such artists as Picasso, Braque, Miró, and Chagall had been involved even before the war. Soon many abstract artists of the Informel movement who were well established, and whose painterly styles were appropriate for print mediums, were encouraged by publishers to make prints. A significant body of work resulted.[13] In the late 1950s and the 1960s there was an increase in printmaking in the United States, not a surprising fact given the preeminence of American Abstract Expressionism and then Pop Art. Important print workshops such as Universal Limited Art Editions and Tamarind opened, attracting some of the most significant artists of the day. A print boom followed, with a proliferation of new workshops and publishers in England and Germany as well. Abstract artists such as Robert Motherwell, Sam Francis, and Helen Frankenthaler,[14] as well as imagists Jasper Johns, Robert Rauschenberg, Jim Dine, Richard Hamilton, David Hockney, and others would become major printmakers, beginning at nearly the same moment as Tàpies. New workshop facilities also appeared in Spain. The Informel generation made prints there and abroad, as did artists of subsequent movements.

Although certain print techniques have flourished intermittently during the contemporary period, Tàpies has worked continuously with lithography and intaglio. Adding the collagraph technique, carborundum, flocking, and traditional collage, he often builds a sculptural relief on traditionally flat surfaces, developing a remarkable tactility that corresponds to his work in painting and appeals to the fingertips as well as to the eyes. In his paintings he often stamps objects into cementlike surfaces, leaving records of their existence. With printed work he establishes this "record" with embossing techniques, sometimes imprinted without ink from the back of the paper. In collagraph three-dimensional objects are affixed, or collaged, to the

are, "always a question, always a surprise,"[24] and he vividly recalls the changes in Tàpies's expression as he witnesses the results.

Polígrafa, unlike publishers Sala Gaspar, Erker, and Maeght, did not become involved with prints through a connection to the art world. Instead it began as a commercial printing company in 1914.[25] In the early 1960s, through Manuel de Muga—the second generation of the family at Polígrafa—the firm began publishing art books, and eventually prints. Presently the firm is directed by Manuel's son, Joan de Muga, and its vast printing facility (for both commercial and fine art printing) is located a short drive from downtown Barcelona. Galeria Joan Prats, which was opened by de Muga in 1976 and has locations in Barcelona and New York, exhibits Polígrafa prints along with painting and sculpture.

Tàpies began publishing prints with Polígrafa in the early 1970s, and has created over one hundred individual prints and fifty prints for illustrated books and portfolios there. The factorylike atmosphere of the workshop and the uniformed technicians belie the intimacy and rapport that exists between Tàpies and the master craftsmen. Working with the intaglio printers, Tàpies created a tactility in his prints that exceeded anything he had achieved up to that point. The enthusiasm of his printers is evident when two of them, Eloy Blanco and Salvador Martí, describe their intaglio work with Tàpies, "from whom we learn something each time we work together."[26] Since Tàpies's approach demands printmaking innovations, they "sometimes consult books," so they will understand how to proceed. The resulting combination of etching, carborundum, and collagraph often gives Tàpies's prints a raucous vitality that makes those created in France appear highly refined in comparison. In lithography two technicians, Federico Soto for printing and Joan Vidal for preparation of the plates, describe Tàpies's involvement as he presses his hands on the plates or walks across them to create his art work.[27] Their sophisticated equipment allows him great freedom of expression.

Since 1988 Tàpies has published prints and books with Edicions T, Barcelona, directed

21

by his eldest son, A. Tàpies-Barba. Tàpies-Barba, a poet, is particularly interested in publishing illustrated books and is closely involved with the conception of these projects as well as the details of their design and production.[28] He also encourages Tàpies to work with young local printers. For a 1990 project involving thirty prints, Tàpies worked with master printers Joan Roma and Takeshi Motomiya. Roma has said that he feels a certain humility about working with such a renowned artist, but that he is not reluctant to make suggestions because Tàpies is so open to new materials and techniques.[29]

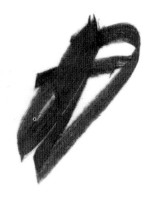

Prints

Tàpies's prints evoke a charged, visceral response to their tactile surfaces, and a resonant associative relationship with their complex symbolism. The artist achieves this through formal strategies and thematic notions that have evolved over four decades and now constitute a recognizable and refined artistic vocabulary. By examining the artist's approach to materials, composition, theme, and motif the viewer can appreciate the function of this vocabulary to illuminate meaning. First is his relationship to the flat surface of the paper support, which he combats with various print techniques, and to its rectangular shape, which he foils by incorporating irregular shapes into his compositions. Second is his mode of pictorial writing, explored variously in letters, words, and cryptic texts; in a crossmark "X" in numerous permutations; and in calligraphic signs that appear Eastern in derivation. Third is his involvement with his homeland, Catalonia, which is a source of pride and protest. And fourth is the subject of human presence, which he portrays through the human body and through renderings of everyday objects.

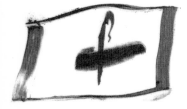

SURFACE AND SHAPE
In Tàpies's earliest untitled lithographs, referred to as the Black Lithographs and executed in

1959, he devised unusual methods to achieve surface patterning. He sprinkled sawdust, and sprayed ink from mosquito sprayers or squeezed it through cracks in broken glass. In Untitled (pl. 1) he produced an all-over atmosphere that relates to the mysterious, suggestive ambience of his Matter Paintings, but with an ethereal quality that calls to mind the otherworldly. By adding a horizontal line at midpoint, however, Tàpies also alludes to a horizon and links the worldly and the spiritual. In the recent *Espiral [Spiral]* (pl. 2) of 1989, comparable surface effects demonstrate Tàpies's long-standing preoccupation with such issues. Here the artist uses the collagraph technique to create ridges that waver in an undulating rhythm and call to mind raked sand. The gesture needed to bring out those lines is comparable to similar gestures used in Tàpies's paintings, where the artist trowels his "matter" medium onto the surface. In *Espiral* the flowing pattern evokes a reverie, interrupted by graffiti of a black spiral and random numbers that bring the viewer back to the everyday world. This linking of otherworldly experience with worldly realms is a fundamental component of Tàpies's art.

In the late 1960s and early 1970s Tàpies's interest in tangible references to reality, expressed through surface tactility, led him to radically alter the conventional concept of the print. In both *La Paille [Straw]* (pl. 3) of 1969 and *Le Crin [Horsehair]* (pl. 4) of 1971, Tàpies collaged materials that are found in many of his paintings and assemblages of the period to his printed surfaces. The horsehair in *Le Crin*, even though something coarse, is composed in such a way as to evoke a primordial fire. The straw in *La Paille*, though a barnyard staple, is through composition also given an unexpected interpretation. Its linear structure relates to the abstract painting of the period, and a visual tension is created between abstract formal properties and the rough material.

Tàpies attacks the flatness and smoothness of paper by applying flocking and collagraph to simulate fabric in Untitled (pl. 5), a 1962 lithograph. In addition, the irregular shape against the rectangle of paper produces the sense of a floating fragment, a means Tàpies often

23

employs, and one that induces enough irregularity to add surface activity while also alluding to a state of process and transformation. In *Graphisme sobre paper [Strokes on Paper]* (pl. 6) the artist adheres common brown paper onto the background sheet using the pressure of the printing press. The resulting fragment shape, which seems embedded in the paper, resembles a piece of chamois upon which a secret message is found. Such references to mysterious, unknown realms are recurrent in Tàpies's work.

WRITING

Secret messages and ambiguities of meaning underlie the scriptlike writing Tàpies employs as a major structural component. Words have been utilized in paintings throughout the history of art, and in the twentieth century this practice has been widespread; major examples are Cubist collage and Surrealist automatism. In the contemporary period Georges Mathieu, Hans Hartung, and Pierre Soulages have created linear markings that take the shape of written signs; and other artists, Cy Twombly in particular, have made writing fundamental to the meaning and structure of their work.

Tàpies relationship to writing—in a handwritten, automatist-derived form rather than with collaged typography—is tied to his absorption in the complexities that underlie reality, the transformations that constantly occur in what we perceive as reality, and the relationship of that reality to spirituality. In one approach Tàpies sets up a field upon which he writes or scribbles indecipherable words, sometimes systematically filling a sheet of paper as if it were a written page. Such notations suggest the profoundly unknowable, as well as the familiar nervousnous of ordinary doodling. Closer inspection often yields recognizable words or letters, as if bits of real experience were caught up in a larger network of incomprehensibility. With these tantalizing clues one feels there might be a hidden code just beyond one's grasp.

With *Graphismes et deux croix [Writing and Two Crosses]* (pl. 7), vague horizontal lines

24

surface of a plate. Paper is then placed over this prepared plate and run through the press, creating a relief effect. With carborundum, a particular form of collagraph, a compound of carbon and silicon is applied to the plate and painted on or molded by the artist. After inking, the compound leaves a grainy texture on the paper, in addition to surface relief. When flocking is added, tiny bits of material are sprinkled on glued areas to achieve a velvety texture. All these techniques of surface manipulation are closely linked to the meaning in Tàpies's prints, but also parallel unusual surface techniques employed by other contemporary printmakers. Examples include the embossing of Pierre Courtin, Etienne Hajdu, Günter Uecker, and Omar Rayo; the reliefs of Rolf Nesch; the gouged, broken surfaces of Fontana; the heavily inked textures of Burri; and the carborundum passages of Miró.[15]

Publishers and Printers

As has been noted, a unique aspect of printed art is the collaborative aspect involving publisher, printer, and artist, three creative forces with defining roles in the creation of the work of art. Although some artists make prints in the privacy of their own studios, many contemporary painters begin print projects at the suggestion of a publisher, who provides the initial resources to undertake them. The publisher hires professional printers, distributes the edition, and ultimately shares in the profits from sales. Under this system publishers make creative decisions as to which artists will make prints (in some cases, an artist might never begin printmaking otherwise), which printer will work with an artist, and the nature of the particular project.

The skills of professional printers are a resource of which artists readily avail themselves. In the modern period this collaborative printmaking goes back to the late nineteenth century, when French artists such as Toulouse-Lautrec, working with master printers, prompted a flowering of color lithography and a revival of fine-art printmaking. By the mid-

twentieth century print technicians, or "master printers," proliferated and developed an enormous repertory of techniques, usually in response to the challenges of an artist's vision. Tàpies has taken full advantage of the technical imaginations of the printers with whom he has worked. As he states about his master printers, "We are always in a dialogue." One of these, Damià Caus of Barcelona, concurs: "I always remember Tàpies's prints because of the complexity of the technique and because of the union of artist and technician—two people with one idea."[16] Tàpies has created most of his printed work with printers provided by his five primary publishers: Sala Gaspar in Barcelona; Erker in St. Gallen, Switzerland; Maeght and Lelong in Paris; and Polígrafa in Barcelona. Recently he has also begun to work with young Barcelona printers hired by Edicions T, the firm established by his eldest son.

Sala Gaspar, the publisher who in the late 1950s first began working with Tàpies on sustained print projects, was established by the Gaspar family in 1909 and still occupies the same site in the center of Barcelona.[17] Initially a frame and reproduction business, it opened as a gallery in 1927, was interrupted by the Civil War, and was reestablished in 1939. In the late 1950s Miquel and Joan Gaspar, cousins who ran the gallery and exhibited Tàpies's work there, invited the artist to make his first lithographs. According to Tàpies, the Gaspars, who held very daring exhibitions during the restrictive Franco years, were also courageous in allowing him freedom to experiment with printmaking. Master printer Damià Caus worked with Tàpies at the Gaspars' Foto-Repro Workshop in Barcelona. A charming individual and stimulating technician, according to Tàpies, Caus would never say no. "Nothing was ever too difficult for him; everything was always possible." Caus has said that he was challenged by Tàpies, and that when they worked together, "hours would go by, without either of us realizing it—when we finally looked up it would be 10:00 o'clock at night!" And then Caus "could not sleep" until he had figured out technical solutions for Tàpies's ideas. "The hardest work, and the most satisfying work, was always with Tàpies," says Caus.

In the early 1960s Tàpies moved for a time with his family to the picturesque Swiss town of St. Gallen in order to create a mural in the town's Handels-Hochschule Library. He established there what would be a long-standing relationship with the Erker-Galerie and their printing and publishing facilities, Erker-Presse and Erker-Verlag. Established in 1958, Erker is owned by Franz Larese and Jürg Janett.[18] Like Sala Gaspar, Maeght, and Polígrafa, it combines gallery exhibitions and workshop printing with the publication of art and related books, limited-edition prints, and deluxe illustrated books, on a model that is common in Europe but has no precise counterpart in the United States. Larese and Janett encourage artists who exhibit at their gallery to become involved in printmaking. For illustrated books the publishers select an author who is sympathetic to an artist's vision. This was the case in bringing together Tàpies and the German psychoanalyst and philosopher Alexander Mitscherlich for the illustrated book *Sinnieren über Schmutz*, a text concerning mud that the publishers thought appropriate for Tàpies. Erker also organizes lectures and symposia with artists, writers, and theoreticians and in conjunction with them publishes lithographs that include the artist's composition together with a writer's text.

In the Erker lithography workshop Tàpies uses traditional methods on stone, which he initially employed with master printer August Bühler, "a typical craftsman who served his apprenticeship in the old days of the printing industry."[19] Since Bühler, Tàpies has worked for many years there with Urban Stoob, "a very good humored man," according to Tàpies, who gathers all sorts of unusual materials in anticipation of the artist's visits. "The printer prepares strange materials to stimulate my thinking—shirts, shoes, unusual instruments, bits of wood."

In 1967, through the initiation of French poet and art historian Jacques Dupin of Galerie Maeght in Paris, Tàpies began to exhibit there. This association brought with it a long relationship with the distinguished printing and publishing arm of this well-established gallery.[20] From its early years, Galerie Maeght had forged a link between the exhibition of

19

unique art works and the publishing and printing of related monographs, art and literary reviews, catalogs, deluxe illustrated books, limited-edition prints, and posters. Aimé (1906–1981) and Marguerite Maeght (1909–1977) had opened their Paris gallery in 1945, and Aimé Maeght, who was himself a trained lithographer, always described his profession as publisher (*éditeur*), and sometimes as editor (*directeur de revue*), but never as paintings dealer (*marchand de tableaux*).[21]

As a result of the interest of the Galerie Maeght and the opportunities it provided, Tàpies's commitment to printmaking accelerated. During the 1960s, 1970s, and 1980s, Tàpies created over three hundred prints published by Maeght, Maeght/Lelong, and then Lelong.[22] In addition he produced five illustrated books and seven issues of Maeght's distinguished periodical *Derrière le Miroir*, which contained artists' lithographs and texts by poets, writers, and critics, and also served as the catalog for gallery exhibitions.

In Paris Tàpies first worked in Maeght's Arte workshop, a large building with several floors devoted to lithography and etching, as well as to offset printing for art books and catalogs. There he began his relationship with master printers René Lemoigne for lithography and Robert Dutrou for intaglio.[23] The intaglio processes were the most complex, and Tàpies marvels that Dutrou is "so wise—he knows every technique." Tàpies fondly recalls Dutrou's amusing comment about a particular print, "I know how to improve this!"

While publishing prints with Maeght and then Lelong, Tàpies has also worked with Barcelona printers. He continued his association with Damià Caus for lithography, and by the mid-1970s began a long relationship with master intaglio printer Joan Barbarà. In 1976 alone Tàpies collaborated with Barbarà on fifty prints published by the Galerie Maeght branch in Barcelona. Barbarà's intimate print shop, located in a Barcelona townhouse, is convenient to Tàpies's own residence, and the printer is joined there by his sons, Virgil and Tristan. Tristan Barbarà has characterized the almost "magical" quality of Tàpies's etching, where the results

him feel what he calls naturalistic mysticism, a vocation for mystery and for a mysterious communication with things, without any need to believe in supernatural factors."[31] With its basis in the intermingling of mind, body, surroundings, and spirit, Eastern philosophy expresses Tàpies's beliefs in one essential reality, rather than separate realities.[32]

Calligraphic line is found in the work of a variety of artists, particularly those of the Informel generation. (The work of Alechinsky, Soulages, and Franz Kline, among others, all include it.) Tàpies himself has pointed out the affinities of his work and that of Motherwell and Mark Tobey, mentioning these artists' interest in Eastern thought and culture. Tàpies's calligraphic signs, and his writing imagery generally, usually suggest a hidden communication, even where spare forms and muted tonalities foster contemplative moods.

In *Petit t [Small t]* (pl. 26), Tàpies makes gestural strokes that reads as both a character from an Eastern alphabet and a landscape. Similarly, a landscape quality is evident in No. 17 from the series *Variations sur un thème musical* (pl. 29) and in *En Forme de montagne [Mountain Shape]* (pl. 28), here deriving from a configuration that could also be a mathematical sign. *Vertical* (pl. 27) of 1984 indicates literary narrative, both through the format of a hanging scroll and through the gestures themselves that imply a reading from top to bottom. *Cadira [Chair]* (pl. 30), another vertical print resembling a wall hanging, seems to contain simply calligraphic brushstrokes on a burlap background. Upon sustained viewing, the brushstrokes cohere into the outline of a chair. What was assumed to be the threads of burlap are actually their printed impression, taken through monotype. Again Tàpies has combined the contemplative and spiritual with the everyday.

CATALONIA

A major source of subject matter in Tàpies's work is the artist's relation to Catalonia and the "Catalan spirit."[33] In referring to his homeland, Tàpies says, "my country, Catalonia," which

might surprise those who consider him a Spanish artist.[34] But the regions of Spain have strong identities, with differences in traditions, culture, and sometimes even language. As far back as the tenth century Catalonia existed as an independent region, occupying the northeastern corner of the Iberian peninsula.[35] It exhibits cultural links with the area that extends over the Pyrenees into southeastern France, and the Catalan language, with affinities to both French and Castilian Spanish, is one of the nine Romance languages.

Catalonia's political status has varied, with the region existing sometimes autonomously and at other times as part of a larger Spanish state. In the medieval period, when Catalonia was one of the most important powers of Europe, its art, architecture, and literature flourished. A strong Catalan literary tradition is a source of pride and perhaps, in part, the reason the language itself never died out even when unsupported by the state. Another period when Catalan culture flowered was in the nineteenth century, with the Romantic movement called the Renaixença (rebirth) and the Symbolist movement, Modernisme, an equivalent of art nouveau. In 1931 self-government was again in place in Catalonia, but at the end of the Civil War in 1939 Franco ended this autonomy and banned the language on radio and television, as well as in schools. The effect of this prohibition was so deeply felt as to have been characterized by some as "cultural genocide." Since 1975 and Franco's death the Catalan language has been reinstated and political autonomy granted.

Catalan art, like its language, is linked to both Spanish and French art, with the attendant Romantic and rationalist characteristics. The Catalan sensibility is often described as part *seny* (good sense) and part *rauxa* (passion). One critic states, "Catalan art ranges from orderly, idealistic images to libertine belligerence, from the purest lyrical tension to the most hermetic and symbolic romanticism."[36] Although Tàpies's work is more closely aligned to the passion, symbolism, and mysticism associated with *rauxa*, it is buttressed with the rigor and reason of *seny*.[37] Tàpies is an intellectual and theorist who reads widely and writes extensively, and while

30

he acknowledges a predisposition toward the emotional, he also incorporates the rational into his art since he believes both qualities are necessary.[38] His art attests to a compositional structure and a thematic consistency that rely on a framework of logic; yet his interest in magic and alchemy and in the writings of the medieval Catalan mystics is also pervasive.[39]

Tàpies's inextricable bond to his Catalan heritage may reflect, in part, his desire to be in touch with a personal authenticity that will in turn connect him to the essential reality that he believes is shared by all people and all things. Since one's unconscious is, in some measure, defined by one's native surroundings, Tàpies may be nurturing this cultural tie by remaining in his native Barcelona when other cities would have offered him freedom from political repression and intellectual isolation. When asked why he never left, Tàpies simply says, "I am Catalan."

Although references to Catalonia appear throughout Tàpies's oeuvre, they are concentrated in both his paintings and printed art of the late 1960s and early 1970s. In 1972 he published the *Suite Catalana* with Gustavo Gili of Barcelona, a publisher with a long family history in book publishing. In plate l from the *Suite Catalana* (pl. 31), Tàpies uses the structure of the Catalan flag—four red bars on a yellow field—to create a powerful visual statement of emotion and protest. The red bars become streaks of blood and refer to the legend that the medieval Count of Barcelona, before dying in battle, traced a blood-soaked hand down his golden shield. For Tàpies the four red strokes become a battle cry, filled with anger and anguish for the repression of Catalan culture. The frenzy of emotion is heightened by names from Catalan history and art strewn across the flaglike sheet. Their voices all seem to be shouting *"Visca Catalunya!"* ("Long Live Catalonia!"), a cry heard at demonstrations during the Franco period. Tàpies has said: "I want to inscribe on my paintings all the troubles of my country, even if I have to displease: the suffering, the grievous experiences, the imprisonment, a gesture of revolt."[40]

31

In *Visca Catalunya* (pl. 34), an intaglio from 1976, the violence of Tàpies's feelings is vividly enacted. The spontaneous and autographic quality of the blood-red letters prompt the viewer to identify with the terrifying action depicted in the print, and thus with the theme itself. A sculptural tactility achieved through carborundum contributes to the sense of immediacy and what seems to represent the remains of battle, and perhaps the last gesture before a gruesome death.

Tàpies pays homage to the customs of his country in plate 2 of the *Suite Catalana* (pl. 32) by referring to the sardana, a local folk dance performed in a circle and danced outside the Cathedral in Barcelona throughout the Franco years. Here Tàpies personalizes the dance by using his own foot to make imprints, and by naming family and friends as partners. The inexplicable yellow notations and numbers in the center add an irrational element, as if they have sprung directly from the unconscious.

In *Quatre rius de sang [Four Rivers of Blood]* (pl. 33), Tàpies again refers to the Catalan flag with a backdrop of names of Catalan poets, painters, and architects, and the cry "*Visca Catalunya!*" Here Tàpies expands the surface potential of white paper to create Braille-like raised words, achieved by squeezing a plastic material (which then hardens) onto the etching plate through a frosting dispenser. This method, devised by his printers at Polígrafa, enabled the artist to write easily.

The four red strokes become a potent signal, a kind of logo that appears in many of Tàpies's works, sometimes almost clandestinely without direct reference to Catalonia. In *Ditades damunt diari [Fingerprints on Newspaper]* (pl. 35) of 1975, Tàpies creates a composition with broad calligraphic flourish that, since it is printed on a background of newsprint, is immediately in the realm of daily experience. Four red strokes succeed in turning this conception into another reference to Catalan identity. In *4 Barres rouges [Four Red Strokes]* (pl. 37) of 1972, a particularly subtle use of the symbol is found, interestingly, in a print published in

serve as guides for Tàpies's scratched writing forms, giving them a barely intelligible structure. A mouth with teeth is entangled in the random marks at the lower left center, and recognizable numbers and letters are scattered throughout the seeming chaos. A sense of irrationality is heightened by numerical sequences in reverse, though such reversals are a normal outcome of the etching process. The rough, bitten line—another characteristic of etching—contributes to an overall agitation. The sculptural dimension and texture of the carborundum technique give two crosses figural presences, as they are witnessed communicating through the etched lines that link them.

The 1972 *Pissarra [Blackboard]* (pl. 8) represents an object found in several of Tàpies's paintings of the 1960s and early 1970s. When cryptic indications occur on such a commonplace schoolroom implement, tension is created between the worlds of the unknown and the familiar. The carborundum technique is again employed for sculptural effect, reinforcing a sense of tangibility. In *Oeuvre gravé [Printed Work]* (pl. 9) of 1974, through the technique of lithography, the meaning of the words seems to be revealed by the soft glow of an inner light. But comprehension remains beyond reach, as one strains to understand what appears to be a manuscript page, complete with deletions and corrections.

Isolating single letters and making them serve as the carriers of the message is another strategy of Tàpies's. When iconically placed they become symbols, while simultaneously registering a certain modesty as simply recognizable units of the alphabet. Some critics have analyzed Tàpies's choice of particular letters, most often the "M" as it appears in Untitled (pl. 10). They have variously interpreted it as alluding to death (*mort*), to the drapery swathed around the Christ figure in the descent from the cross, to the lines in the palm of the hand, or to a woman's spread legs. Often, however, randomness itself is part of a letter's meaning, placing the experience of it either in a familiar or in an associative realm of the viewer.

When Tàpies brings letters together, meanings vary, intimating something personal or

resembling a public declaration, as in graffiti. In *Signic [Signifier]* (pl. 13) the letters can be understood as a hidden word, or as an "A" and "T" between quotation marks. In either case the configurations are elegant calligraphic signs that are soothing in effect. *Fora [Go Away]* (pl. 14), on the other hand, expresses anger and violence with its harshly drawn letters. "Fora" is the Catalan expression for "go away," and red and black, found here and frequently in Tàpies's printmaking, were the colors of the anarchist flag during the Spanish Civil War.

In certain instances Tàpies's letters become specific. One of his most frequent motifs is the combination of "A" with "T," or the representation of each alone. As with his other disconnected letters, the "A" and "T" can be read as merely letters of the alphabet or as having personal meaning. They are not only Tàpies's initials but also the first letters in his name and that of his wife, Teresa. In both cases the letters bear an identity that results in their becoming actors in a compositional drama created by the artist. In *L'Echelle [Ladder]* (pl. 15), a lithograph of 1968, he invents a lonely and vulnerable presence from an "A." The print's large scale relates the letter to life-size and gives it special significance, while an "X" scrawled across the middle becomes a variation of "T," and confirms the autobiographical element. The title, however, identifies this "A" as a ladder, an ordinary piece of equipment often appearing in Tàpies's paintings.

In two prints executed ten years apart, *Esperit català I [Catalan Spirit I]* (pl. 16), an intaglio of 1974, and *A.T.* (pl. 17), a lithograph of 1984, Tàpies's subject remains basically the same, but its characterization changes. Both prints personify "A" and "T" and place them in communication. *Esperit català I* utilizes the collagraph technique, wherein burlap affixed to a plate produced letters in relief that duplicate the coarse weave of that material. *A.T.* is ghostlike in comparison, with flowing lithographic letters that suggest the varnish medium that preoccupied Tàpies in the 1980s. Here the process of transformation is implied as brushstrokes become letters that might soon dissolve into simple matter. Tàpies confirms their specific iden-

26

tity by adding on "a" and "t" at either side of the sheet and at the bottom left. The otherworldly effects and seemingly symbiotic linking in *A.T.* contrast with the lowly material, factual outlining, and direct communication of *Esperit català I.*

The metamorphosizing relationship between the letter "T" and the ubiquitous cross-mark "X" in Tàpies's work is clearly demonstrated in *X de vernis (Varnish X)* (pl. 23). Signs at each corner appear to transform themselves as they move around the sheet, and in the process anchor the fluid, barely tangible "X" of the central motif. The cross-mark "X," as a variation of a "T" and thus a reference to the artist, is again in *X-A* of 1975 (pl. 18) and *AT* of 1985 (pl. 19). Once more the later print is replete with flowing, calligraphic gestures while the earlier work has clearly articulated signs that resemble equations. In addition to representing different periods in the artist's work, the two prints represent different printshops. *AT*, from Polígrafa in Barcelona, displays the extreme palpability that is typical of intaglio works Tàpies has created there. Its dramatic color and lack of margins add to an effect of vivid emotionality and expansiveness that identifies the work with that shop. In contrast *X-A*, which was created in intaglio with Dutrou in Paris and published by Maeght, achieves velvety surfaces and rich though muted color. Ink is brought out across the margins, creating a subtle framing device that contributes to the print's overall refinement. Clearly, different workshops bring out different aspects of Tàpies's artistic personality.

When Tàpies uses the "X" alone, it often functions as a "brand," with the artist taking possession of something in the composition. When applied forcefully, or violently, the "X" also serves to negate. In No. 1 from the series *Variations sur un thème musical [Variations on a Musical Theme]* (pl. 22), a lithographic spray technique is used for quickly outlining a skull over which an "X" is scored. The "X" serves to identify Tàpies and also negate death. A loosely drawn geometric cross enclosing the image implies a link to the spiritual world.

The branding function is found also in *La Grande Porte [The Large Door]* (pl. 21). The

27

physical nature of a door is underscored here by an irregularly raised surface resembling wood fissured by weather. Yet Tàpies also creates a persona from this functional structure. Large in scale and rooted to the ground, his door anthropomorphizes into a firmly standing figure. The ambiguity of its shape encourages its interpretation as something mysterious and primordial, or perhaps even a gravestone. An "X," collaged with tape, confirms the artist's possession of the object and his personal identification with it.

A geometric cross is a further permutation of Tàpies's "T." In *M 1/2* (pl. 24) of 1984, it represents the absolute in a pure and evocative black. In *Aparicions 2 [Apparitions 2]* (pl. 25), such a cross is both personage and icon. Through collagraph and carborundum Tàpies simulates cardboard — even the corrugated ridges visible between torn layers — and adds a touch of the coarse and common. In this print he also writes the letters "a" and "b," which could be interpreted as either random inscriptions on a discarded box, or as part of a universal ordering system. (Actual cardboard is frequently used as a support by Tàpies, sometimes flattened out from an opened carton and forming a geometric cross.)

In *Personnage assis [Seated Figure]* (pl. 20), a personified geometric cross again can be interpreted as signifying the artist himself. Transformation is implied as the bottom segment mutates into a foot, in a linkage of the cross and the foot that is a recurring autobiographical motif in Tàpies's work. A coarse rag and random scribbling are included, and tend to temper the reverent spirituality implied by the large scale and iconic placement of the image.

In the 1980s Tàpies's writing often stressed a calligraphic flow and rhythm. This direction has a basis in his engagement with Eastern art, a source of inspiration since the 1940s. "Like yoga exercises and Buddhist koans and kasinas, I attempt in my painting . . . to develop a technique which will inspire meditation and ultimately enlightenment," Tàpies says.[30] One critic, referring to Zen Buddhism in particular, has pointed out, "The mystery of Zen suited Tàpies's mentality, which, without the emotive basis of his childhood religiousness, soon made

Paris. Spare, eloquent, and minimalist, with a refined palette and rational geometric structure, this intaglio reveals new meaning when one understands the relationship of its elegant red calligraphic strokes to Catalan culture.

In addition to prints and paintings on the subject of Catalonia, Tàpies has also produced several books and portfolios reflecting his profound connection to his homeland. With Brossa he created *Poems from the Catalan*, a 1973 portfolio, and another in 1974, *Als mestres de Catalunya*, dedicated to a group of teachers who hoped to reintroduce the teaching of Catalan. He collaborated in 1973 with Catalan poet Pere Gimferrer on *La clau del foc*, an illustrated book for which Gimferrer chose a selection of poetry by Catalan writers and Tàpies provided the illustrations.

Tàpies's interest in Catalan literature begins with Ramon Llull, the thirteenth-century figure he characterizes as a "poet, mystic, philosopher, scientist, and man of action," and who is considered the first major writer in the Catalan language. His admiration is based on Llull's writings and his modernity, which Tàpies believes resides in the integration of mysticism and science. Many of the Llull editions in Tàpies's own collection of rare books contain illustrations and diagrams he especially admires. It is not surprising that in honor of this unusual figure he conceived the illustrated book *Llull-Tàpies* (pl. 39), which occupied him intermittently for over ten years. It contains a selection of Llull's writings chosen by Gimferrer, a critical text on Llull by specialist Miquel Batllori, and illustrations by Tàpies. The book's grand size and horizontal format, which opens to a double-spread of over three feet, is in itself an homage to the monumental Llull. Other references to him abound in Tàpies's work. In the print *Tres R [Three R's]* (pl. 38) of 1975, for example, the centralized letter "R" refers to Ramon Llull, and also to two other Catalan Ramons: Ramon de Penyafort, a writer of church law, and Ramon de Sibiuda, a theologian. The spattered margins of this print contribute to an idea of intellectual fervor.

33

A modern Catalan writer important for Tàpies's intellectual and aesthetic development was Surrealist poet J. V. Foix (1894–1987), who was an inspiring figure in Barcelona before and after the Civil War. It was the Surrealist tradition of Foix, passed on to Brossa, that nourished Tàpies in his formative years. In 1984 *L'Estació* (pl. 40), an illustrated book of Tàpies and Foix, was published by Carles Taché of Barcelona, who initiated the project and oversaw the design.[41] Foix's text is based on a dream about death, and Tàpies responded to it with a ghostly vision of automatist strokes rendered in rich aquatint tones of black. The unconscious itself seems to speak. Tristan Barbarà, who printed it with his father, Joan, remembers that with these prints, "Tàpies created magic—something that is not easy with etching—he created magic with fire and acid."[42]

Catalan issues are the basis of many of Tàpies's posters as well. Whether to celebrate a television station broadcasting in the Catalan language or to inaugurate a Catalan cultural congress, he has enlisted his pictorial strategy of writing, in these cases with specific information, to bring attention to local issues.

HUMAN PRESENCE

Although some consider Tàpies an abstract artist, figural and other referential elements are consistently found in his art. Some of his most potent subjects surround the human presence and can be found in his work as early as the 1940s. In the Matter Paintings of the 1950s and early 1960s, human references occur even among the seemingly inexplicable traces that give those paintings their enigmatic aura. By the mid-1960s the figure becomes a primary motif and has been so in much of Tàpies's art since, especially that of the 1980s.

Tàpies's figures are not representational in the realist sense, nor are they usually depicted whole. Rather, their presence is implied through body parts or imprints from the artist's own body. These fragments evoke a whole—whether a whole body or whole universe.[43] The

34

way they function as abstract components in an overall pictorial structure contributes to this sense that they are integrally tied to something larger. Since they appear to be in a process of either becoming or disintegrating, a constant state of evolution is also conveyed.

"Body parts" is the appropriate term for Tàpies's human fragments since it communicates their unidealized quality. He does not view the body as an expression of archetypal beauty or a standard of perfection, but instead emphasizes the unpleasant aspects of physicality—its potential awkwardness or the unattractiveness of bodily functions. Tàpies's pictorial world declares the inescapability of one's body, with the inconveniences and indignities that sometimes connotes. One lowly member found frequently in his work is the ignoble foot. He has said, "I've had a good time painting things that are not considered very noble or fit for art. You know, things like feet that swell or are dirty or even smell bad. They're not heroic subject matter, and that amuses me. . . . I feel that these pictures communicate a sort of fundamental human solidarity."[44] In *Le Pied [Foot]* (pl. 41), an intaglio of 1969, the artist draws an indeterminate mass that only slowly congeals into an ungainly foot scattering dirt. The conspicuous hairs on the ankle contribute to its disagreeableness, particularly as a subject for art.

In the 1980 untitled lithograph from *Suite 63 x 90* (pl. 43), there is a degree of idealization in the curvaceous portrayal of a knee, which is counteracted by equally imposing imprints of the sole of the artist's foot. A scribbled addition to this knee, resembling graffiti, puts the leg simultaneously in another position, and thereby conveys transformation. These parts are brought together in a spare and elegant composition that, uninterrupted by margins, conveys purity by emphasizing the whiteness of the paper, while a centralized geometric cross adds a final note of sacredness.

Dismemberment is the most immediate idea communicated in *La Cama [Leg]* (pl. 42), an intaglio of 1975. An awkwardly placed leg, possibly even an artificial limb, becomes part of a compositional equation, personalized by the familiar "A" and "X." This pictorial scheme sug-

35

gests an attempt to formulate an ordering system, which is given universality by an atmospheric, all-encompassing background tone.

Shoes become part of Tàpies's symbolic foot imagery in *Empreintes de pas [Footprints]* (pl. 46) of 1972 and *Sabata [Shoe]* (pl. 47) of 1989. They, and the person walking in them, are austerely represented in *Empreintes de pas*, wherein an upward orientation and centralized placement of footprints, an even pace of interval between them, and a dark background color foster a sense of order and calm. The collaged sand takes on a mythic dimension as it calls to mind a slow walk in an arid desert. The intaglio *Sabata*, on the other hand, emphasizes mundane humanity with a clumsy shoe, individualized by Tàpies through the letters "A" that try to fill it, and with the crossmark below. Adhered to the larger sheet is a background of brown paper, similar to common wrapping paper.

Arms and hands also play a role in Tàpies repertory, although not as frequently as feet and legs. Again these body parts function both as abstract compositional forms and as symbols. In *Signes et bras [Signs and Arm]* (pl. 44) of 1976 and *Empreinte [Imprint]* (pl. 45) of 1984, the placement of the arm gives this body part the status of an icon. In *Signes et bras* the identity of the vivid pink shape is ambiguous: the angle at midpoint could be an elbow or a knee. An overlay of lines segmenting the sheet, and numbers in each section, impose rational order in a system-making strategy that is persistent in Tàpies's work. The shadowy, macabre arm in *Empreinte* is a stark contrast to the fleshy, vital appendage in *Signes et bras*. Rather than drawing the likeness, Tàpies has laid his arm onto the etching plate, with the result resembling an x-ray. An eerie atmosphere hinting at death pervades the print, a subject that appears often in Tàpies's work of the 1980s. Irregular indentations produced by carborundum suggest decay or even a surface riddled by bullets. Collaged gauze recalls bandages, while crosses extending from the fingers add both a personal and a supernatural ingredient.

Since the 1940s Tàpies has employed the handprint, and by extension the fingerprint,

the universal mark of identification. While he clearly intends to introduce himself through this concept, he has also stated, "In the laying on of hands there is something that suggests thaumaturgy, talismanic intentions, praying attitudes, something that clearly has its origins in traditional magic-symbolic impulses of the collective subconscious, brought up to date by the Surrealists and used, quite rightly, by a whole new culture."[45] With *Empreintes de mains [Handprints]* (pl. 48) of 1969 Tàpies makes handprints in a composition filled with agitated markings that are the residue of the etching and inking processes. Fingers appear to separate from palms, and the hands become three fists raised in protest. An interlocking, horizontal chain reads as barbed wire, and red-brown strokes above suggest blood, in an interpretation that is linked to the period of worldwide social and political turmoil in which this print was made. Although produced in Paris, the site of major student protests, it signifies generalized protest.

Sexuality is found throughout Tàpies work, at times almost hidden within the overall compositional structure and at others quite explicit, even shocking. In Untitled from the series *Cartes per a la Teresa [Letters to Teresa]* (pl. 49) of 1974, Tàpies sets up his usual duality of abstract shape and representational motif with a figure seen unflatteringly from the back. Buttocks are the striking feature and sex is indeterminate. In *Matière et graffiti [Matter and Grafitti]* (pl. 50) of 1969 and No. 12 from the series *Variation sur un thème musical* (pl. 51) of 1987, male sexuality is represented. In the 1969 intaglio sexual imagery is integrated into a relatively delicate formal structure of chalklike jottings on a pitted surface. The reference to graffiti is clear, yet not as explicit as in No. 12, where gestures and forms are aggressively drawn and simulate those lewd, angry messages encountered in the street. A textured background of raised musical notations produced through collagraph sets up an ironic backdrop of refinement.

In *Tors [Torso]* (pl. 55) of 1988 Tàpies employs a spray that spreads freely into the margins of the sheet, achieving a sense of movement or flux. This haunting male torso appears to

37

be a harbinger of death, with firm overmarkings providing the only tangibility to the immateriality of the ghostly body. The chaotic atmosphere is punctuated by autobiographical indications of a cross and an "a-t."

A preoccupation with death in Tàpies work is contrasted with an acknowledgement of the humorous aspects of human physiognomy. He chooses to glorify the nose, the ear, and the tooth in *Grand Nez [Large Nose]* (pl. 54) of 1984, *Orella [Ear]* (pl. 52) of 1972, and No. 10 from *Variation sur un thème musical* (pl. 53) of 1987. Against only an expanse of large white paper, the nose takes on the identity of a calligraphic character in *Grand Nez*. The size of the sheet dramatizes the subject. A red crossmark claims this huge facial feature as Tàpies's own, while its color and blurring brushstrokes also suggest blood. Baseness and humor are joined to the nobility of the emblematic calligraphic sign. In *Orella* a dismembered ear is centered in a minimalist field. Cryptic writing makes this now iconic organ part of one of Tàpies's enigmatic equations. In No. 10 a huge tooth becomes ferocious. Its depiction as a huge still-life object bestows the symbolism of that tradition.

EVERYDAY OBJECTS

Even in the late 1940s and early 1950s Tàpies represented everyday objects in his work. Throughout the 1950s such elements were used occasionally, and by the late 1960s and early 1970s they were a primary concern and constituted a repertory of particular items: scissors, clothing, housewares, furniture, and even bits of string and rope. He also collaged objects onto his paintings, or imprinted their shapes into the cementlike material that made up their surfaces. In the 1980s he produced sculptures of them. His purpose in focusing on these articles is to "sacralize the immediate world" and "discover beauty in everyday things." He acknowledges that "in this attitude there is an element of provocation, a desire to cast down the old false idols."[46]

38

In the long tradition of still life, representations stand not only for themselves but often form part of a referential system. While Tàpies has remarked that "the whole universe can be contemplated in something little or insignificant,"[47] it is the human connection to ordinary objects that is poignantly recalled in his work. They are also often anthropomorphized, representing the artist himself, as well as all human beings.

Clothes make the most direct reference to people, particularly since Tàpies often portrays them as they would be worn. In *Camisa [Shirt]* (pl. 56), of 1972 and *Dentelle [Lace]* (pl. 59) of 1977 the artist uses actual clothing to create his printed works on paper. In *Camisa* Tàpies manipulates the collagraph technique, in which a shirt is adhered to a plate, stiffened with glue, and then run through the press with paper over it, producing a raised surface that approximates a garment. When the print hangs on the wall, viewers relate to the shirt at just about the height at which they might see it on themselves in a mirror, thereby accentuating the sense of reality. The idea is further personalized by discovering that this shirt and other items of clothing often belonged to family members.[48] But by inscribing the bottom of the sheet with his own signs, Tàpies himself lays claim to it.

In contrast to the materiality achieved in *Camisa*, Tàpies creates an atmosphere of intangibility in *Dentelle* through lithography. The women's camisole becomes a glowing apparition, an interpretation reinforced by the cloud-shaped forms around it. With a handprint and other gestures, Tàpies possesses the subject; by scribbling in breasts in crude graffiti-fashion, he links everyday reality to the otherworldly. Socks and handkerchiefs are also recurring motifs, found here in *Mouchoir [Handkerchief]* (pl. 57) of 1971, and *Mitjó [Sock]* (pl. 58) of 1972. The drapery folds of *Mouchoir*, enhanced with hand additions, add a certain luxuriousness to this utilitarian piece of cloth. But the nose being blown at the upper right brings the image back to basics. In *Mitjó* the centralized placement of the sock, and the incorporation of the white paper as an active part of the composition, lend an ironically contemplative mood to

39

this composition based on a humble item of clothing.

Chairs of various kinds—straight-backs, sofas, padded boudoir chairs—are important subjects for Tàpies. "Look at the simplest of objects," he has said. "Take an old chair, for instance. It seems to be nothing at all. But think of the whole universe that it contains . . . Even the oldest chair still has in it the initial strength of the sap that came up out of the earth in far-off forests, and that will still manage to give off some heat the day the old chair is broken up and thrown on the fire to burn."[49] Chairs are also his most frequently anthropomorphized objects. In *Chaises [Chairs]* (pl. 60), a large-scale intaglio of 1981, he sets two straight-backs face-to-face in dramatic confrontation. The heavily etched lines running between them express intense communication: a dialogue fraught with agitation, made tangible by the raised surface of the intaglio technique. This communication is reflected in Tàpies's statement, "there's a current of life that unites people. When I look at someone I'm talking to, I don't see that person in a void. The two of us are joined in a flow of curiosity or sympathy or whatever. Everybody, everything depends on other people, other things. There's no real separation . . . between the observer and the observed."[50] With all their tangibility, however, these chairs are made up of the most abbreviated abstract lines and are placed in an amorphous, undefined setting. Again a sense of otherworldliness coexists with the day-to-day.

With *Grande Chaise [Large Chair]* (pl. 61) of 1984 Tàpies creates a humanized shape that could refer to the artist himself. Its vulnerability, indicated through its compositional placement and its relation to the empty setting, recalls the persona established in the "A" in *L'Echelle* (pl. 15). In addition, a ceremonial and even religious interpretation is intimated by the geometric cross centrally placed at the bottom of the sheet. Personification is made explicit with *Vernís cadira (Varnish Chair)* (pl. 62) with a mouth and teeth added near the top of a chair and a human leg added to the chair's leg. A layer of silkscreen creates the flowing effect of varnish implying an evolving world where a chair can easily transform itself into the familiar "A,"

joined by an "X." A quickly drawn heart at the top lends a certain specificity, as if this composition might represent a loved person.

In many of Tàpies's works the apparatus of daily life—scissors, pieces of string, silverware, dishes—is acknowledged as ordinary, but also given special distinction. However, it does not usually contain the anthropomorphic dimension found in his subjects of clothing and chairs. Here the commonplace itself is elevated to the level of the symbolic. In *Les Ciseaux [Scissors]* (pl. 64) and *Cercle de corde [Circle of Rope]* (pl. 65), inkless intaglios of 1969, Tàpies gives simple household items eloquence and spirituality again through the stragegy of emblematic placement and a focus on the whiteness of paper to communicate a calming purity. The open scissors hint at the identity of the artist in their reading as an "X," while the rope circle, in its simplicity and completeness, could be a calligraphic sign. Yet both prints stress essences, as does *Gerra [Pitcher]* (pl. 63), an intaglio of 1989. Here the sandy surface and elegant white outline are hard and impervious, recalling the phrase "etched in stone." Even with Tàpies's familiar crossmark brand, and his signs that are "poured" from the pitcher, the overriding expression of this print is not about the personal, but about essence: the essence of the object, and Tàpies's ongoing attempt to find an essential reality.

Illustrated Books

Some of the finest achievements of Tàpies's printed oeuvre are the illustrated books he has done in conjunction with writers. The pictorial qualities of writing stressed in his compositions provide a natural complement to the typography of texts. The imagery, incorporating his full array of surface, sign, and symbol, does not strictly illustrate the words of the poet or author, but rather parallels it. He has said that his work is a kind of visual poetry, and that it occupies a territory between art and literature.[51]

Tàpies is an avid reader of poetry and essays and a distinguished essayist himself. He

may be unique among contemporary artists in that he has published six books of essays on art and culture, as well as a memoir. Although his life is built around making art, books and reading are also central components of it. A two-story library is an important room in his house. Its special atmosphere is different from that of his painting studio, but both rooms represent the world of the artist. His library is filled with rare editions dating back to medieval Catalan texts, and includes poetry and philosophy of the East and West that he treasures as both a reader and a collector. He knows the location of each book, and displays an almost childlike enthusiasm for sharing his treasured objects. For Tàpies they are imbued with a kind of magic. His delight is evident as he handles them, admiring the arrangement of the type on the page, fascinated with diagrams and illustrations, and even enjoying the smell of the old volumes. This love of the physical aspect of books is reflected in his incorporation of old parchment covers as painting supports, and in his terra cotta and bronze sculptures of books. With his interest in books for their literary content as well as for the physical pleasures they offer, it is not surprising that Tàpies has created over thirty illustrated books.

Tàpies's first published illustration for a page was for *Dau al set* (meaning "the seven-sided die," an impossible phenomenon), the adventurous, virtually clandestine, avant-garde magazine founded in Barcelona in 1948. The irrational concept encompassed in the magazine's title was in keeping with the Surrealist tendencies of the group involved, and Tàpies's illustrations were in a Surrealist style, depicting creatures and landscapes that could inhabit only dreams. In the July-September 1949 issue (pl. 66), Tàpies contributed a "text" of indecipherable words, scratched out in a line linked directly to the mouth of a diabolical self-portrait, as if in a stream from the unconscious. "Words" and likeness are integrated both formally and psychologically.

The period of the *Dau al set* periodical is closely associated with the beginning of Tàpies's friendship with Joan Brossa. He recalls, "My friendship with Brossa, rather than

marking a new stage in my career, practically coincided with the beginning of it. This is possibly because he was somewhat older than me, and from the very first I looked upon him as someone with greater self-confidence, someone who knew what he wanted and who was heading straight for his goals."[52] This association of artist and poet, remarkable for both its longevity and the creative output that resulted from it, has been made tangible through their many collaborations on illustrated books. The art critic Roland Penrose has said, "Their intimacy is such that it could be said they share the same shadow."[53]

Brossa's poetry, with its affinities to Surrealism, incorporates simplicity of language to express the complexity of appearance and the irrationality behind it. Tàpies has said, "there is nobody better than Brossa at extracting poetry from just such things as the creaking machinery of stage sets and trapdoors, from the stiffest of contrived rhymes, from the stink of the typeface and inks in old printing presses—even from the most commonplace television commercials and video clips."[54] In recent years Brossa has created a body of visual poetry that joins words and letters with images. In what he calls "object poems," he uses actual objects to form unlikely juxtapositions. When he affixes rhinestone earrings to the earphones of an old headset (*Música*, 1986) the audacity of the combination reveals a sensibility that relishes life's unpredictable realities and combines poignancy, humor, mystery, and eloquence. Tàpies, with his more solemn temperament, would find such intellectual vitality, combined with lightheartedness, irresistible. He has characterized Brossa as an animator, a kind of living force in Barcelona.[55]

The printed collaborations of Tàpies and Brossa have taken the form of illustrated books, portfolios with prints and poetry, and single sheets, which comprise over a dozen works of art. As early as 1949 Tàpies published two albums of etchings containing the poetry of Brossa. In *Tres aiguaforts* (pl. 67), a brief Surrealist passage by Brossa is included with three hand-colored etchings. The small size of the prints and their complex drawing style foster an

43

intimacy that draws the viewer into a private world filled with the provocative iconography of Tàpies's Surrealist phase: checkerboards, pyramids, piercing eyes, and twisting, anthropomorphic vegetation. Unevenly inked plates have given an eerie glow that is heightened by subtle hand-coloring.

The unorthodox nature of many of Brossa's and Tàpies's collaborations is evident in their first illustrated book, published by Sala Gaspar in 1963. *El pà a la barca* (pl. 68) ignores the conventions of the distinguished, primarily French, illustrated-book tradition, wherein poets and painters collaborate on luxurious *livres d'artistes*. Tàpies has said that as publishers the Gaspar cousins were very open-minded about the outcome of a collaboration with Brossa, and this unusual volume offers continual surprises, as the vitality of their experimentation is still felt. (Gaspar himself has noted that although Tàpies's early books were not geared to the commercial market, he knew they would eventually be appreciated.) As the basis of his illustrations, Tàpies chose fragments of unusual, sometimes wrinkled or torn, papers: ruled notebook sheets, brown wrappers, newsprint, or the flap of an envelope. These bits of reality serve as counterpoints for the vaguely melancholic, private world of Brossa's poems, and full-page lithographs provide dramatic accents. The type, chosen by Brossa, is uneven and irregular, suggesting that an old typewriter was used. One poem, with blurred letters, is virtually illegible. Joan Gaspar remembers this blurring was meant to simulate the work of censors, active in Franco's Spain, who might object to a literary work and therefore obliterate it.

Novel·la (pl. 69), a Brossa and Tàpies book of 1965, is a remarkable collaboration both for its physical nature and for its cogent meaning. It describes the life of a man from birth to death and, given the conditions in Franco's Spain, the result is both poignant and powerful. As text Brossa has chosen certificates that will be needed as the individual goes through life, incorporating them as "readymade" pages and creating a life circumscribed by forms. Starting with Birth Certificate No. 339555, milestones are cited, such as high school graduation, mar-

riage, military service, and funeral arrangements. The official forms are sometimes dull—simply questions and blanks to be filled in. At other times they are ornate and suitable for framing. Tàpies's appropriately black-and-gray illustrations interact with the impersonality of these forms. They acknowledge human existence, however colorless, through such details as a hand with a wedding ring, a nose, a foot ("that is when his feet bothered him," says Tàpies), and also vestiges of sexuality. Tàpies's aggressive and unconventional handling of crumbled, folded, torn, and cut sheets suggests the potential freedom of an individual even in the face of enforced regulations. He has said, "*Novel·la* was a way to protest the controls that were everywhere."

Brossa and Tàpies have continued their collaborations through the 1980s. In 1985 they produced a benefit portfolio, *El Rei de la Magia*, to support a local magic shop on the verge of going out of business. Both Brossa and Tàpies have been interested in magic and its basis in transformation since the 1940s, and the cover of this portfolio includes a magic wand attached to the spine. Earlier, in 1969, they had collaborated on a another project involving magic: a book with a portfolio on the renowned Italian magician Leopoldo Fregoli (1867–1936), who performed in Spain and was noted for quick costume changes in which he transformed himself.

Music is also a shared interest of Brossa and Tàpies, going back to the early days of their friendship when they would listen together to Tàpies's record collection. In 1988 Edicions T of Barcelona published *Carrer de Wagner*, which reflects their regard for the nineteenth-century German composer Richard Wagner. The text consists of thirteen poems written by Brossa between 1941 and 1987 on the subject of Wagner and the title refers to the street in Barcelona where Brossa was born, coincidentally named after the composer. For the illustrations Tàpies chose unusually ornate red-and-black coloring that reflects Wagnerian drama. The paper for the etchings is coated with a velvety red flocking and the red paper of

45

the cover is textured to resemble mottled silk.

Tàpies has provided illustrations for the work of a wide range of literary figures in addition to Brossa. He has collaborated with several Spanish language writers, including the older generation of Foix, Rafael Alberti, Jorge Guillén, and María Zambrano, and younger authors such as Pere Gimferrer, José Miguel Ullán, and José Angel Valente. There are also joint ventures with the Mexican writer Octavio Paz, with the Cuban poet Carlos Franqui, and with German scholar Alexander Mitscherlich. Given his ties to Paris and the long tradition of illustrated books in France, it is not surprising that many of his books have been conceived with French poets and publishers. Among those with whom he has worked are poets Yves Bonnefoy, André du Bouchet, Jean Daive, Jacques Dupin, Jean Frémon, and Edmond Jabès, and publishers Maeght, Editions F.B., and R.L.D. of Paris, and Fata Morgana of Montepellier.

Some of Tàpies's volumes have a traditional design that includes single- and double-page illustrations with separate text pages; others integrate illustration with text. Described here will be examples in which the visual component is particularly assertive—through the melding of illustration with text, the unconventional design of the book as an object, or even the active role played by the paper itself.

In 1975 Tàpies collaborated on the illustrated book, entitled only $\chi_{\scriptscriptstyle{>>}}$ (pl. 70), with the young French poet Daive (b. 1941), a student of du Bouchet. Daive had seen the book *Air*, created in 1971 by Tàpies and his teacher, and he asked the artist if he too might work with him on such a project. Tàpies agreed, since he was sympathetic to the young poet's work, with its Far Eastern sensibility garnered from years spent in Tibet. This collaboration takes the form of a small, jewel-like volume, with choice and arrangement of type decided upon by poet and painter together. Placed sparingly, the words cover only a small area of each page, and consequently a climate of whiteness permeates the book. When lines of type are superim-

posed on Tàpies's illustrations, poet and painter seem to speak simultaneously. Even as one turns the illustrated pages, there is an echo of the painter's presence in the deep relief seen from the backs of the printed sheets. His annotations, including a fingerprint, occur occasionally on text pages and add further reminders. The title, usually the responsibility of the author, is here a seemingly mathematical configuration by Tàpies that is frequently found in his work. He ascribes both elemental and optical characteristics to this sign.

Tàpies's annotations play a major role in *Tàpies, répliquer* (pl. 73) of 1981, the artist's second book with Daive, and serve to sustain the dialogue of poet and painter on every page. In this case the text has Tàpies's art itself as its subject, so his gestures serve almost as a rejoinder. They interact with the poet's words in a jazzlike improvisation. This publication was also issued in a trade edition, an inexpensive version that could be widely distributed. *Novel·la* and other of Tàpies's illustrated books were published this way as well.

Ça Suit son cours (pl. 72), published by Fata Morgana of Montpellier, is a 1975 collaboration with French poet Edmond Jabès (1912–1991), who approached Tàpies to do this book and also presented it to the publisher. The artist was attracted to Jabès's poetry, which he characterizes as "torrential—the opposite of simple," and welcomed the challenge of illustrating it. Using the printed text he received from the publisher, Tàpies responded with a dense intermingling of words and letters appropriate to Jabès's theme of words, writing, and literature. Tàpies's remarkable cover, produced with the collagraph technique from actual type, provides a texture of words and phrases taken directly from the text. His illustrations also reflect Jabès's flood of words. One print resembles a writing tablet filled with a kind of hieroglyph; another consists of horizontal lines running the length of the vertical sheet, suggesting a ruled page.

Anular (pl. 74), published in 1981 by Dutrou's publishing firm, R.L.D., was conceived with the young Spanish poet and art critic José Miguel Ullán (b. 1944), then living in exile in

Paris after refusing to serve in the Spanish military.[56] With intaglios incorporated throughout the book, *Anular* is constructed in an unusual accordion format that Tàpies has said evolved naturally as the artist and poet worked together. It creates a world of words: pages are filled with the single-spaced typescript of a political tract—actually an early Spanish Constitution—superimposed with the poet's brief phrases and the artist's large, isolated letters and annotations. Although such letters are common motifs in Tàpies's work, one senses that their sequence on the pages of *Anular* may form a message, a subtext "spoken" by the painter in response to the poet's text. In fact, they can form words or phrases such as "nothingness" or "I command." Tàpies concurs in this interpretation and describes as one aspect of meaning for the work "authority doesn't last." Additional illustrations that add to the impression of dialogue between painter and poet are pages of text that have been cut or torn, at times forming "X's" and geometric crosses. A sense of pervasive irrationality, political and otherwise, is the overall effect.

Petrificada petrificante (pl. 71), published by Maeght in 1978, is a collaboration with the Mexican poet and essayist Octavio Paz (b. 1914). The book came about through the friendship that developed between painter and poet after Paz had seen Tàpies's work. Tàpies feels an affinity to many of the poet's ideas, particularly his sympathy for Eastern thought. The "materiality" of this book, as Tàpies describes it, was his responsibility and he brought a heightened physicality to its otherwise straightforward design of text and discreet illustrations. High relief and rich textures in the illustrations are achieved through carborundum, and a warm, velvety background for the text is provided by a special gray paper, handmade for the project. The text and illustrations are paced in such a way as to climax at a double-page spread that incorporates red and black ink on newsprint and evokes the "fire" and "anger" of Paz's text. Other colors in muted tones allude to his "wind" and "ashes."

In 1975 Tàpies collaborated with Japanese poet and art critic Shuzo Takiguchi

(1903–1970) on *Llambrec material* (pl. 75), published by Polígrafa. A leader of the Surrealist movement in Japan, Takiguchi had met Tàpies at the Venice Biennale in 1958. For this project Takiguchi sent poems to Tàpies, who was responsible for creating the book. Tàpies's choice of paper is dramatic. A warm-toned, tan-colored Catalan *estrassa* paper used by butchers to wrap meat, it exhibits a coarse texture with a pronounced weave and many irregularities in the fibers, and provides surface activity for the otherwise flat lithographs. Takiguchi submitted his poems in Japanese characters in response to Tàpies's request. And Tàpies's artwork, though on separate pages, is clearly in sympathy with the calligraphy of the Japanese writing. The translations of the poems included at the back of the volume reveal that Takiguchi's vocabulary of "air," "wind," "stars," and "sand," alongside "mirrors," "maps," "shirts," and "identity cards," is similar in spirit to Tàpies's.

Tàpies's Mission

A study of Tàpies's printed work sheds light on printmaking in Europe generally, and on the broader development of contemporary art there, both of which differ from their American counterparts. In the case of European printmaking, as Tàpies has experienced it, there is often one structure that links gallery exhibitions, print publishing, and workshop activity and that produces limited-edition prints and illustrated books, as well as ephemeral printed works such as catalog covers, posters, and announcements. The European publisher frequently has ties to literary and intellectual developments in his country that lead to collaborations between artists and writers in books and periodicals. This integration of arts and letters is not as fully developed in America. Print publishing also functions differently here. A typical American publisher may or may not be linked to a gallery or to a print workshop. He or she may match an artist with any of a number of master printers at various shops. And the American printers are themselves often trained in art schools—a very different background from that of the

49

European artisan-printer, who usually has no previous links to the fine arts. Tàpies's print-making has been accomplished primarily with such craftspeople who are part of a long European tradition.

In a wider realm, it is enlightening to view Tàpies as a European counterpart of the American Abstract Expressionist since he is of approximately the same generation. Many of the American artists made stylistic breakthroughs and never altered or surpassed their signature styles. For some, premature death interrupted their artistic development, while for others it was the stifling effects of American celebrityhood. In contrast, Tàpies's artistic evolution has been long and sustained and has been joined with manifold possibilities for experimentation and enrichment. This development may reflect a greater ease with creativity and the artistic process among Europeans.

Tàpies's printed oeuvre attests to the significant role that printmaking can play in an artist's work, as it influences creative thinking through the assimilation of new techniques. Such new techniques have had an especially fruitful effect on Tàpies's work, since he is so attracted to materials and their relationship to content. His approach gives rise to innovation but also respects tradition. For example, he has remarked that he very much enjoys making monumental-sized prints but that their scale tends to remind him that the traditional hand-held print also has its pleasures. Similarly, while he is a master of inventive formats in illustrated books, he also reveres their long-standing conventions.

Tàpies's prints and books round out our knowledge and understanding of his work and thereby deepen our grasp of his overall mission: to provide a vehicle of meaning and transcendence. Art, for Tàpies, is not a decorative object, it is a philosophical system or language that "contains a total vision of the world."[57] He has stated, "I think that the capacity of a work of art to explain reality is a way much clearer and richer—with a much broader range of nuances—than normal language."[58] Through an intricate fusing of formal strategy and icono-

graphic themes, accomplished through an exploration of surface and symbol, he attempts to make visible a dynamic equilibrium between the worldly and the otherworldly, represented by a continuity that embraces the human being, the world, and the spirit. Human presence can be expressed by a scratched mark, a written phrase, a fingerprint, or a fragment of the body. Everyday objects affixed to or depicted in his work form bonds between human beings and their surroundings. Spirituality is explored through tools of abstraction: large scale, strict frontality, empty expanses, atmospheric fields, and emblematic compositions have mesmerizing effects that transport the viewer. Motifs such as the geometric cross provide specific references, as well as balance, equilibrium, and ultimately, transcendence.

As the viewer absorbs the individual elements of Tàpies's artistic language, allowing for their interaction like notes and melodies in music, or words and phrases in poetry, the resulting experience inspires a sense of wholeness and connectedness that is contrary to the disparateness and alienation in modern life. Tàpies has said, "there exists an original Unity or a total and authentic Reality which we share with the universe and all human beings."[59] His art acknowledges the inescapability of bodily functions, the intrusiveness of one's environment, the deep pull of cultural heritage, and the ever-present quest for the spiritual; it does not accept their separateness.

Notes

1. Interview with Antoni Tàpies. All quotes by Tàpies or other information credited to him was gathered during a series of interviews with the author in June 1989 and November 1990.

2. Giancarlo Politi, "Domande per Antoni Tàpies," *Flash Art* (Milan), no. 82–83 (May–June 1978), p. 47.

3. Ibid, p. 46.

4. Michael Peppiat, "Antoni Tàpies: Fields of Energy," *Art International* (Paris), no. 3 (summer 1988), p. 42.

5. For information on Matter Painting generally, see *Matter Painting* (London: Institute of Contemporary Art, 1960).

6. For information on the American reception of Spanish Informelism, see *Before Picasso—After Miró* (New York: The Solomon R. Guggenheim Museum, 1960) and *New Spanish Painting and Sculpture* (New York: The Museum of Modern Art, 1960).

7. For further information on Spanish art during the time of Franco, see *Spain: Artistic Avant-Garde and Social Reality, 1936–1976* (Venice: La Bienale di Venezia, 1976).

8. For further information on developments in Spanish contemporary art see: Manuel Jose Borja (-Villel), *Antoni Tàpies: The "Matter Paintings,"* vols. 1 and 2 (Ann Arbor: University Microfilms International, 1989), pp. 50–51; Perico Pastor, "Spanish Art: Malnourished But Making Waves," *Artnews* (New York), vol. 79, no. 3 (March 1980), pp. 50–57; and Margit Rowell in *New Images From Spain* (New York: The Solomon R. Guggenheim Museum, 1980), pp. 10–20.

9. For a discussion of the Conceptual movement in Barcelona, see *Barcelona/Paris/New York: El camí de dotze artistes Catalans, 1960–1980* (Barcelona: Generalitat de Catalunya, Departament de Cultura, 1985).

10. For a detailed chronology of Spanish art in the 1970s and 1980s see *Antípodas 1988: A Selection—Spanish Current Art* (Brisbane, Australia: World Expo '88: Pavilion of Spain, 1988), pp. 79–123.

11. Robin Cembalest, "Master of Matter," *Artnews* (New York), vol. 89, no. 6, (summer 1990), p. 144.

12. Peppiat, p. 42.

13. For further information on European Informel prints see *Das Informel in der Europäischen Druckgraphik: Sammlung Prelinger* (Munich: Staatliche Graphische Sammlung, 1985).

14. For further information on international Abstract Expressionist prints see *The Spontaneous Gesture: Prints and Books of the Abstract Expressionist Era* (Canberra: Australian National Gallery, 1987).

15. For background information on the sculptural dimension in printing see McNulty, Kneeland, "The New Dimension in Printmaking," *Artist's Proof 5* (New York), vol. 3, no. 1, (spring/summer 1963), pp. 8–17.

16. Interview with Damià Caus, Barcelona, November 1990. All quotes or information from Caus are from this interview.

17. Interview with Joan Gaspar, Barcelona, November 1990. All quotes or information from Gaspar are from this interview.

18. Information on Erker is from an interview with Jürg Janett of Erker-Galerie, January 1990, and from the catalogue *Als Beispiel Erker: Galerie Verlag Presse* (Hagen, Germany: Karl Ernst Osthaus Museum, 1980).

19. Dr. Carl Vogel, Introduction to Mariuccia Galfetti, *Tàpies: Obra gráfica / Graphic Work 1947–1972* (Barcelona: Editorial Gustavo Gili, S.A., 1973), p. xxxiii.

20. For further information on Galerie Maeght and Maeght Éditeur see *L'Univers d'Aimé et Marguerite Maeght* (Saint Paul de Vence: Foundation Maeght, 1982).

21. Adrien Maeght, Introduction to *Derrière le Miroir: 1946–1982* (Paris: Maeght Éditeur, 1983), p. 3.

22. After January 1, 1981, the Galerie Maeght became the Galerie Maeght, S.A. with directors Daniel Lelong, Jacques Dupin, and Jean Frémon becoming partners. After the death of Aimé Maeght in 1981, the gallery became known as Galerie Maeght-Lelong in 1982. Since July 1987 the gallery has been called Galerie Lelong (still with Lelong, Frémon, and Dupin), and Tàpies currently publishes prints under the name of Galerie Lelong. (From discussions with Jean Frémon of Galerie Lelong, New York and Paris, fall 1990.) Galerie Adrien Maeght exists as a separate entity.

23. The Maeght print workshop, Arte, was established in 1965 with Aimé's son Adrien Maeght as the director. A separate workshop, Atelier Maeght, opened in 1977, later becoming Atelier Lelong in 1982. (From discussions with Jean Frémon of Galerie Lelong, New York and Paris, fall 1990.)

24. Interview with Tristan and Virgil Barbarà, Barcelona, November 1990. Quotes or information on the Joan Barbarà printshop are from this interview.

25. Information on Polígrafa is from an interview with Joan de Muga, New York, October 1990, and from the catalog *Ediciones Polígrafa* (London: Redfern Gallery, 1979).

26. Interview with Eloy Blanco and Salvador Martí at Polígrafa, Barcelona, November 1990.

27. Interview with Federic Soto and Joan Vidal at Polígrafa, Barçelona, November 1990.

28. Interview with A. Tàpies-Barba, Barcelona, November 1990.

29. Interview with Joan Roma, Takeshi Motomiya, and A. Tàpies-Barba, Barcelona, November 1990.

30. Antoni Tàpies in Eberhard Geisler, "Leere, Schrift, Vielheit der Sprachen, Uberlegungen zum Werk von Antoni Tàpies," *Iberoamericana* I, (1985), p. 38ff, cited in Marie-Theres Suermann, Introduction to *Antoni Tàpies: Arbeiten 1947–1988* (Bayreuth, Germany: Kunstverein Bayreuth, 1990), p. 8.

31. Alexandre Cirici, *Tàpies: Witness of Silence* (New York: Tudor Publishing Co., 1972), p. 42.

32. For a discussion of Tàpies's links to Eastern art and thought, see Lluís Permanyer, *Tàpies and the New Culture* (New York: Rizzoli, 1986).

33. For a discussion of Tàpies's relationship to Catalan art and culture, see Pere Gimferrer, *Tàpies and the Catalan Spirit* (Barcelona: Polígrafa, 1975).

34. Politi, p. 45.

35. Catalonia is an English word. The Catalan equivalent is Catalunya; the Spanish is Cataluña.

36. Gloria Moure, "New Spanish Painting," *Flash Art* International (Milan), no. 111 (March 1983), p. 50.

53

37. For a discussion of the "Catalan Spirit" see Victòria Combalía, "Tout art national est mauvais; tout art de qualité est national," in *Le Défi Catalan de Picasso et Miró à la nouvelle génération* (Dordogne: Château de Biron, 1988). Further clarification came from discussions with Catalan specialist Mary Ann Newman, affiliated with New York University.

38. Miguel Fernández-Braso, *Conversaciones con Tàpies* (Madrid: Ediciones Rayuela, 1981), p. 63.

39. Gimferrer, p. 32ff.

40. Antoni Tàpies in *La Pratique de l'art* (Paris: Gallimard, 1974), pp. 85-87, cited in *Antoni Tàpies* (Amsterdam: Stedelijk Museum, 1980), p. 10.

41. Interview with Carles Taché, Barcelona, November 1990, and follow-up correspondence.

42. Interview with Tristan Barbarà, Barcelona, November 1990.

43. For a discussion of the partial figure tradition in modern sculpture, see *The Partial Figure in Modern Sculpture: From Rodin to 1969* (Baltimore: The Baltimore Museum of Art, 1969).

44. Peppiat, p. 37.

45. Politi, p. 45.

46. Ibid.

47. Borja(-Villel), p. 211.

48. Discussion with Miquel Tàpies, Barcelona, June 1989.

49. Gimferrer, pp. 56–59.

50. Peppiat, pp. 38–40.

51. Barbara Catoir, *Gespräche mit Antoni Tàpies* (Munich: Prestel-Verlag, 1987), p. 106.

52. Antoni Tàpies, *Memòria personal: Fragment per una autobiografia* (Barcelona: Editorial Crítica, 1977), cited in Miquel Tàpies, "Antoni Tàpies: 1943–1960," in Anna Agustí, *Tàpies: The Complete Works, Volume 1: 1945–1960* (New York: Rizzoli, 1988), p. 491.

53. Preface to Joan Brossa, *Poems from the Catalan*, with lithographs by Antoni Tàpies (London: Guinness Button Publishing Ltd. and Barcelona: Polígrafa, 1973), n.p

54. Antoni Tàpies, "Les Arts d'en Brossa," in *Joan Brossa o les paraules són les coses* (Barcelona: Fundació Joan Miró, 1986), p. 18.

55. Fernández-Braso, p. 66.

56. Interview with Antoni Tàpies, November 1990.

57. Peppiat, p. 40.

58. Borja(-Villel), pp. 220–21.

59. Antoni Tàpies, "A Statement on Art, " in Achille Bonito Oliva, *Antoni Tàpies: Osservatore/partecipante, dipinti e sculture* (Rome: Cleto Polcina Edizioni, n.p. 1988).

Plates

Pl. 1. Untitled. 1959
Lithograph

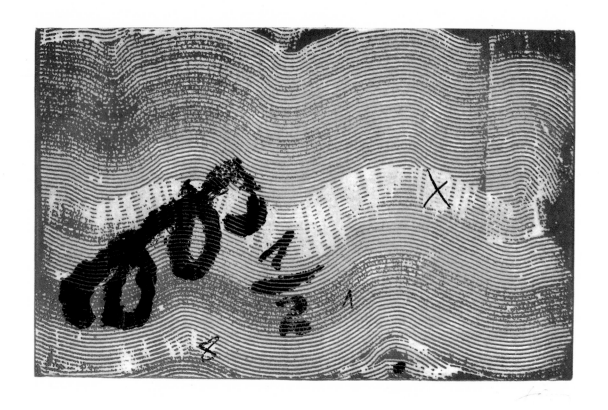

Pl. 2. *Espiral*. 1989
Intaglio, collagraph, and screenprint

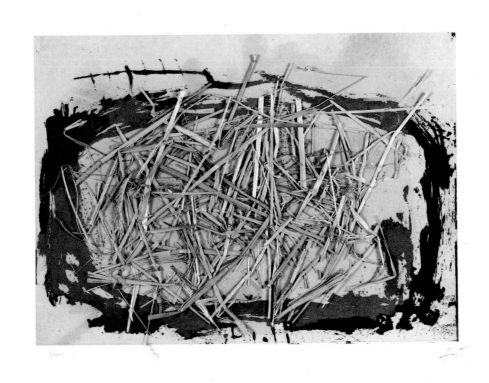

Pl. 3. *La Paille*. 1969
Intaglio on *papier appliqué* with collage

Pl. 4. *Le Crin*. 1971
Intaglio and collagraph with collage

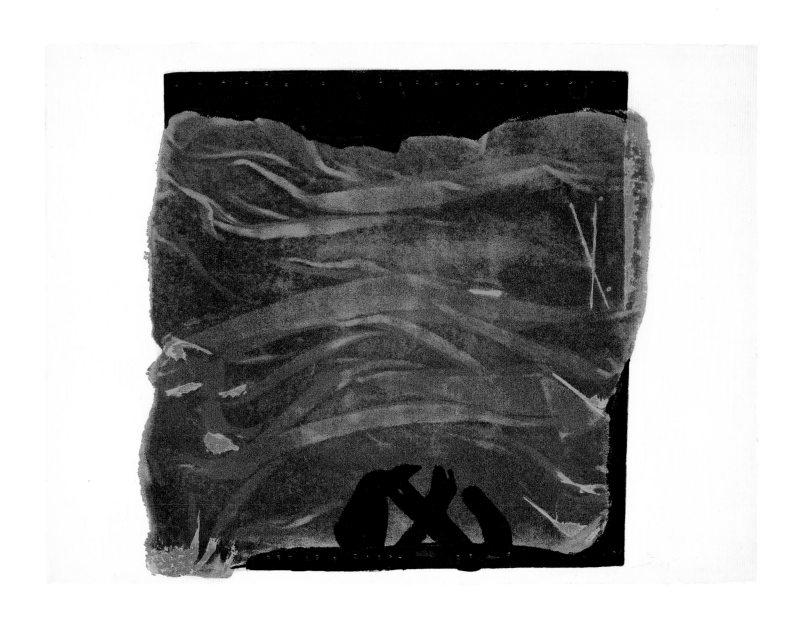

Pl. 5. Untitled. 1962
Lithograph and collagraph with flocking

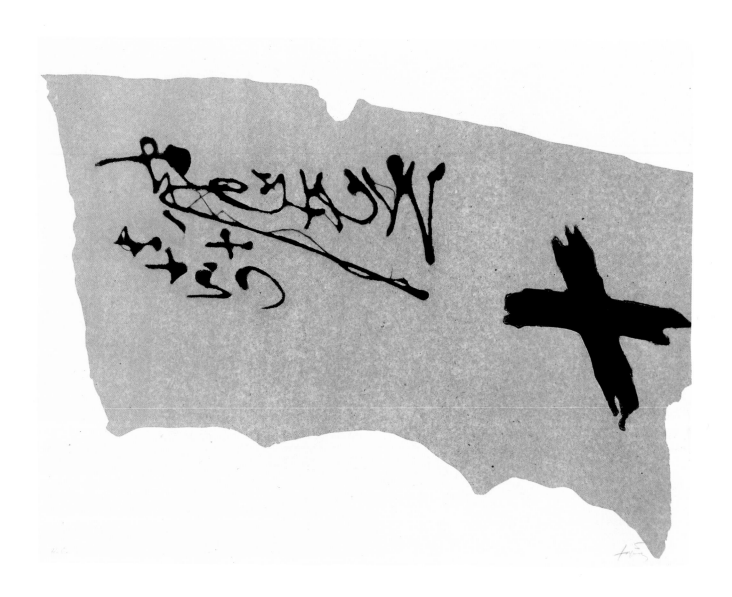

Pl. 6. *Graphisme sobre paper*. 1972
Carborundum on *papier appliqué*

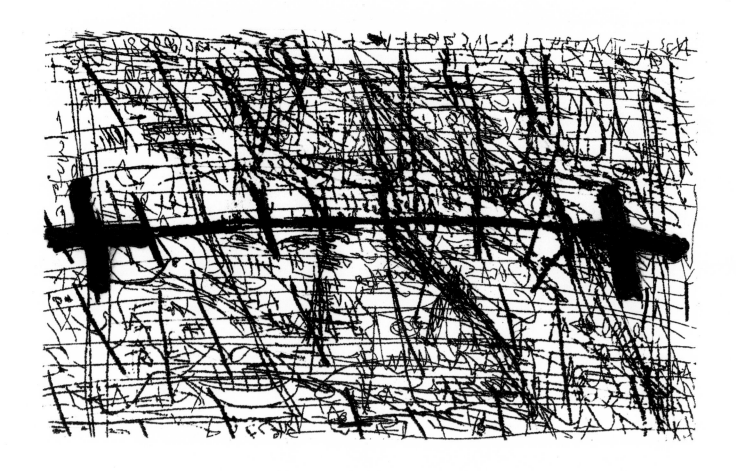

Pl. 7. *Graphismes et deux croix*. 1972
Intaglio and carborundum

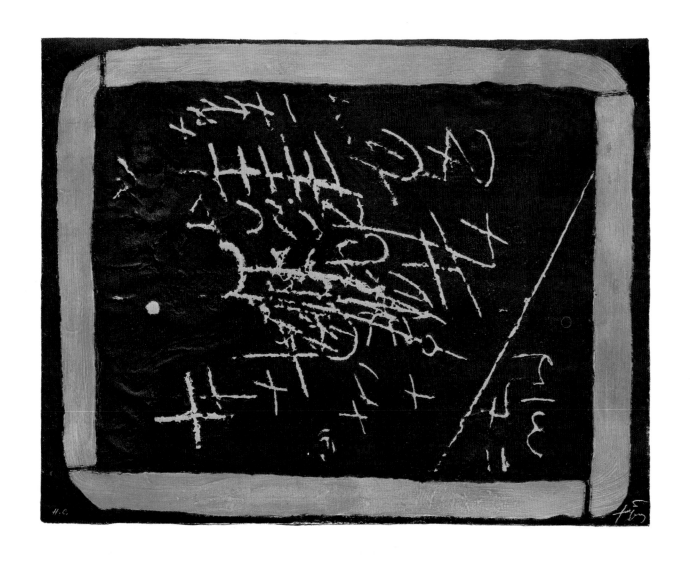

Pl. 8. *Pissarra*. 1972
Carborundum and intaglio

Pl. 9. *Oeuvre gravé.* 1974
Lithograph

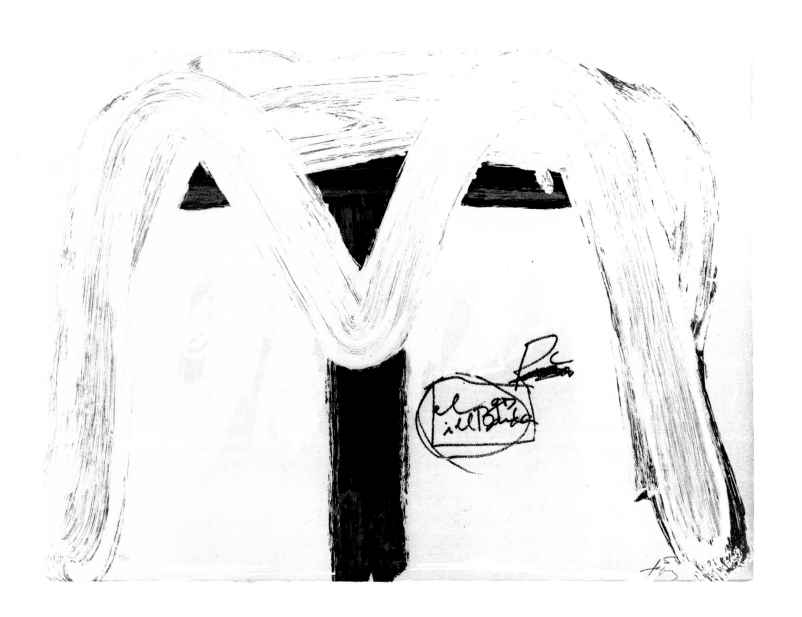

Pl. 10. Untitled, plate 7 from the *Berliner-Suite*. 1974
Lithograph

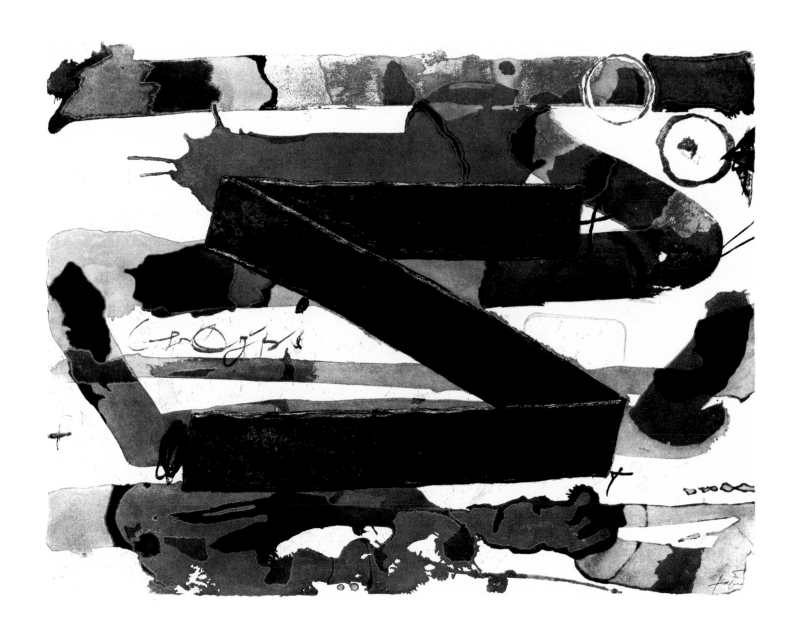

Pl. 11. *Z.* 1979
Carborundum and intaglio

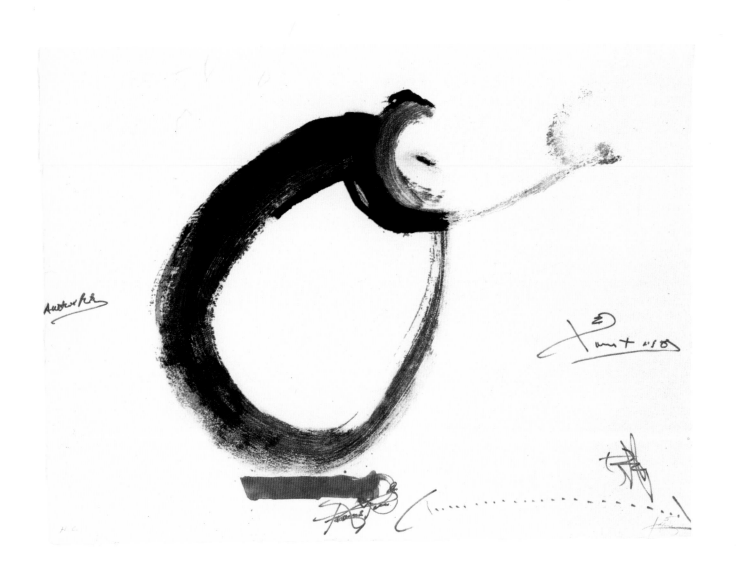

Pl. 12. *Lletra O.* 1976
Intaglio with flocking

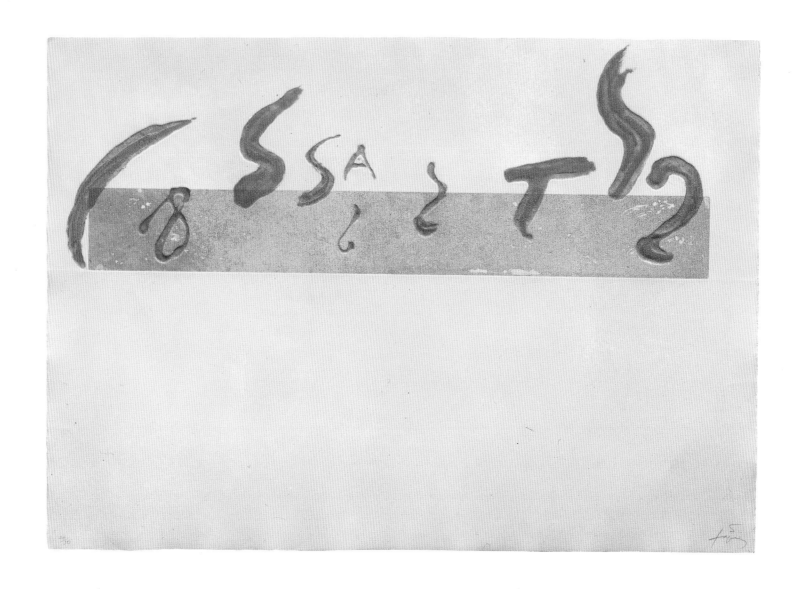

Pl. 13. *Signic*. 1981
Intaglio and carborundum

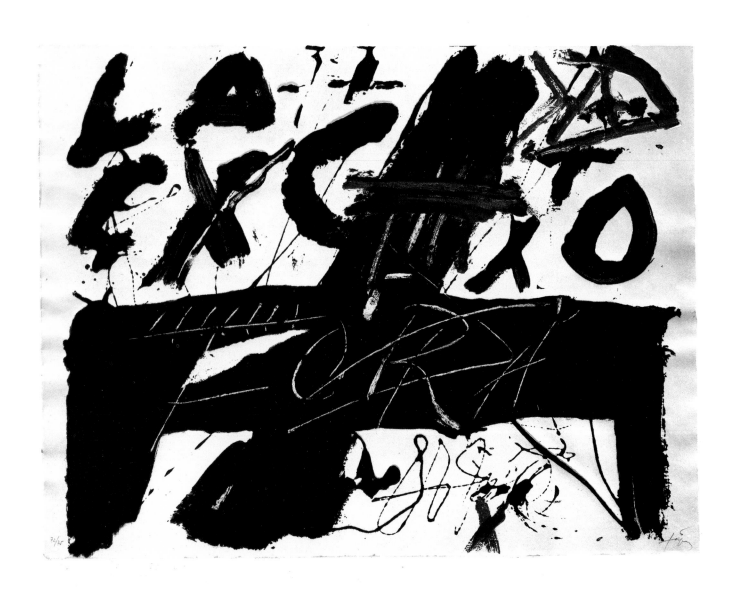

Pl. 14. *Fora*. 1976
Intaglio and carborundum with flocking

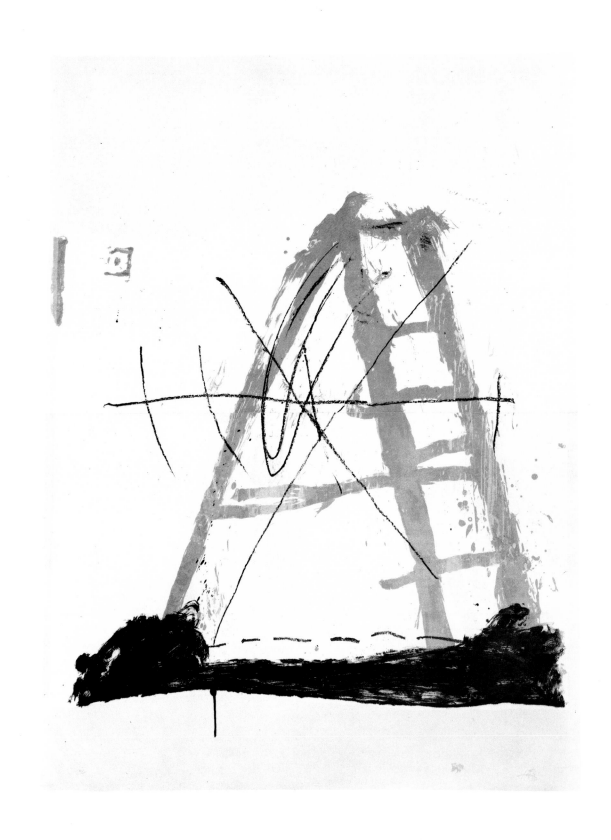

Pl. 15. *L'Echelle*. 1968
Lithograph

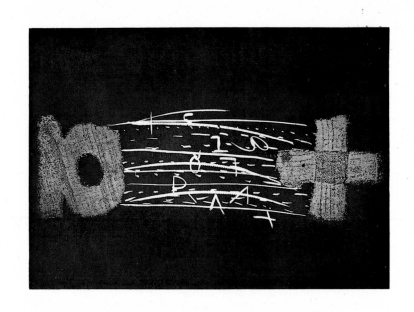

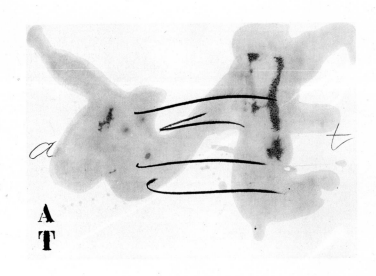

Pl. 16. *Esperit català I.* 1974
Intaglio and collagraph

Pl. 17. *A.T.* 1984
Lithograph

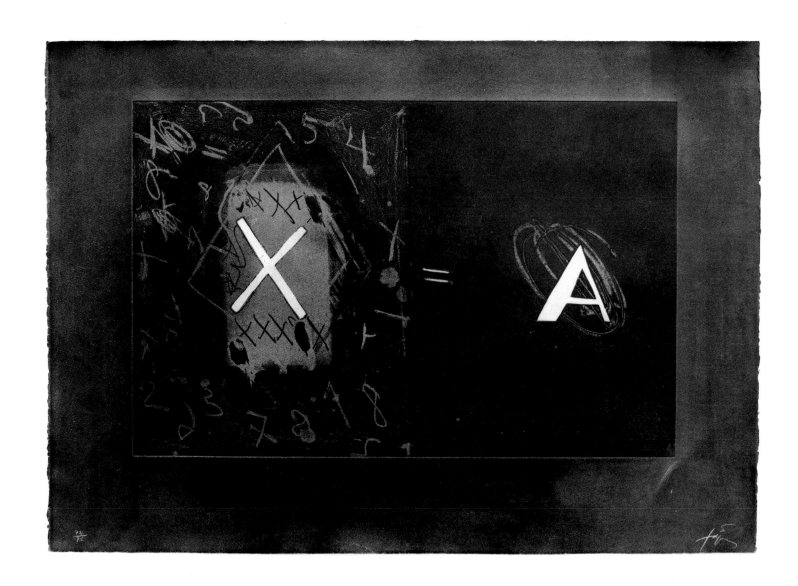

Pl. 18. *X-A.* 1975
Intaglio

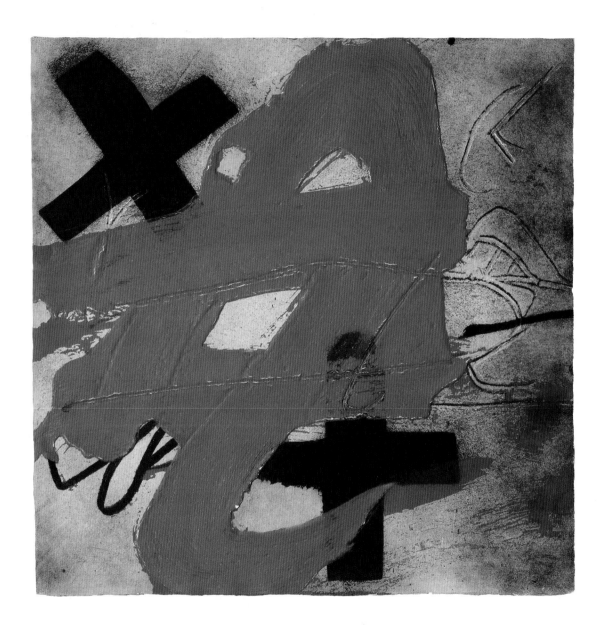

Pl. 19. *AT.* 1985
Intaglio, carborundum, and collagraph

Pl. 20. *Personnage assis*. 1984
Lithograph

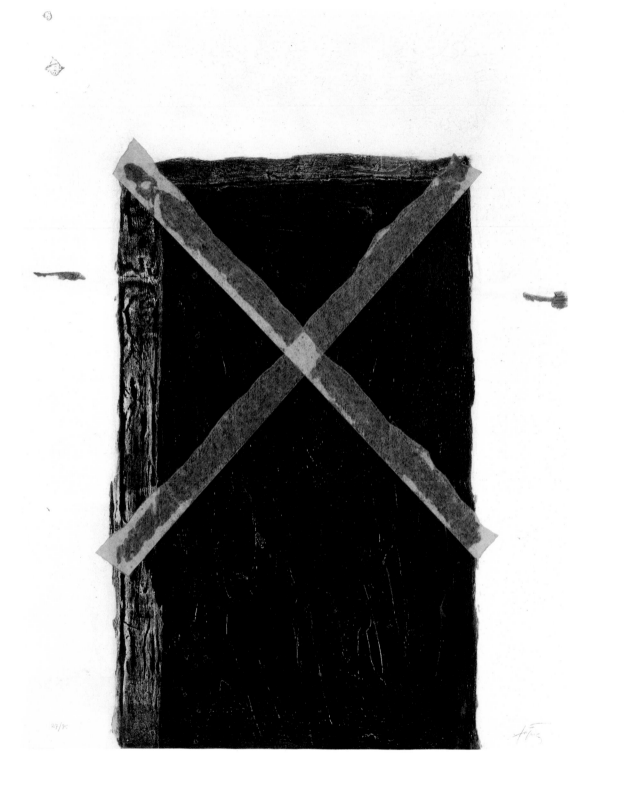

Pl. 21. *La Grande Porte*. 1972
Collagraph and carborundum
with collage and varnish

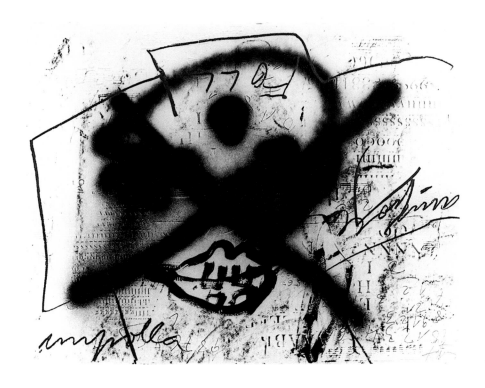

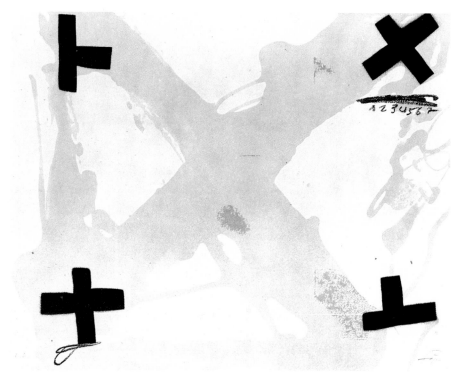

Pl. 22. No. 1 from the series
Variations sur un thème musical. 1987
Lithograph and collagraph

Pl. 23. *X de vernís.* (1982)
Screenprint

Pl. 24. *M 1/2*. 1984
Lithograph

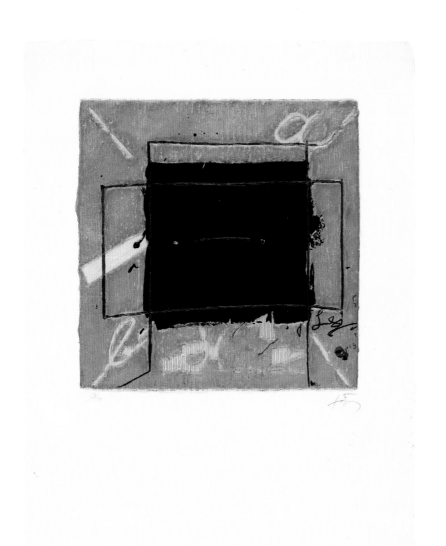

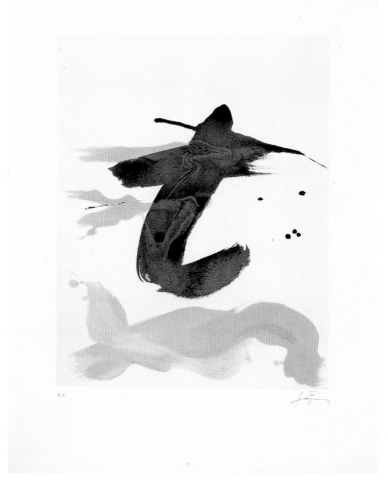

Pl. 25. *Aparicions 2*. 1982
Intaglio, collagraph, and carborundum

Pl. 26. *Petit t*. 1984
Lithograph

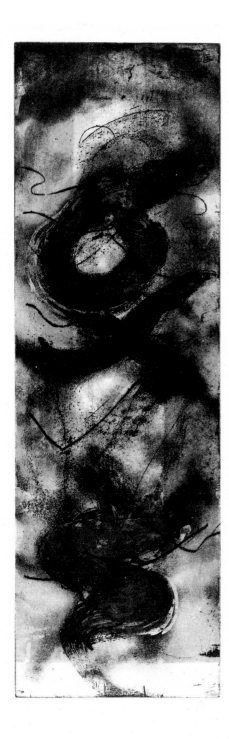

Pl. 27. *Vertical.* 1984
Intaglio

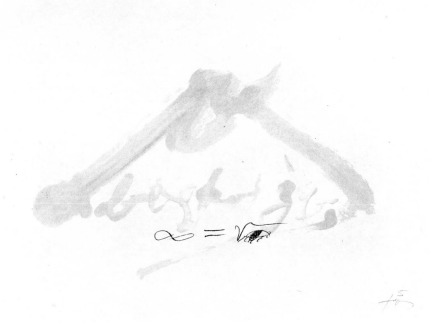

Pl. 28. *En Forme de montagne*. 1980
Lithograph

Pl. 29. No. 17 from the series
Variations sur un thème musical. 1987
Collagraph and lithograph

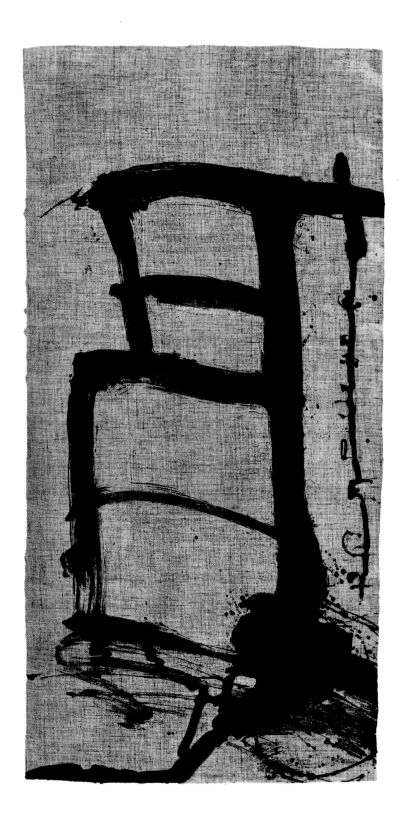

Pl. 30. *Cadira*. 1990
Intaglio on monotype

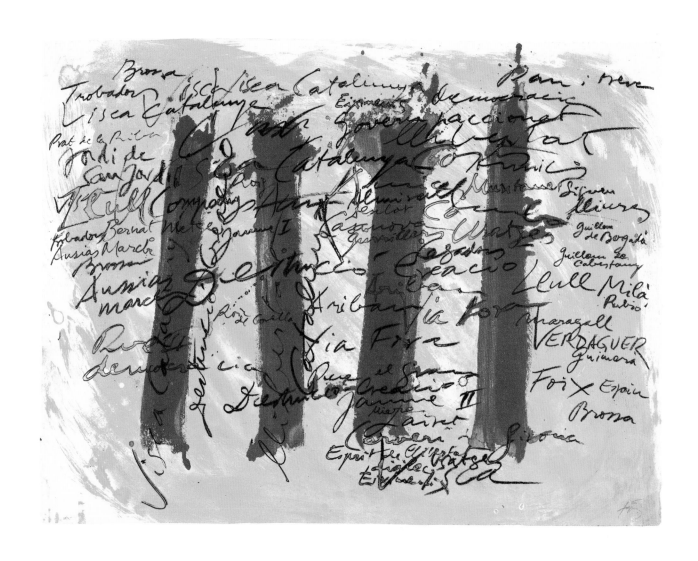

Pl. 31. Untitled, plate 1 from the *Suite Catalana*. 1972
Intaglio

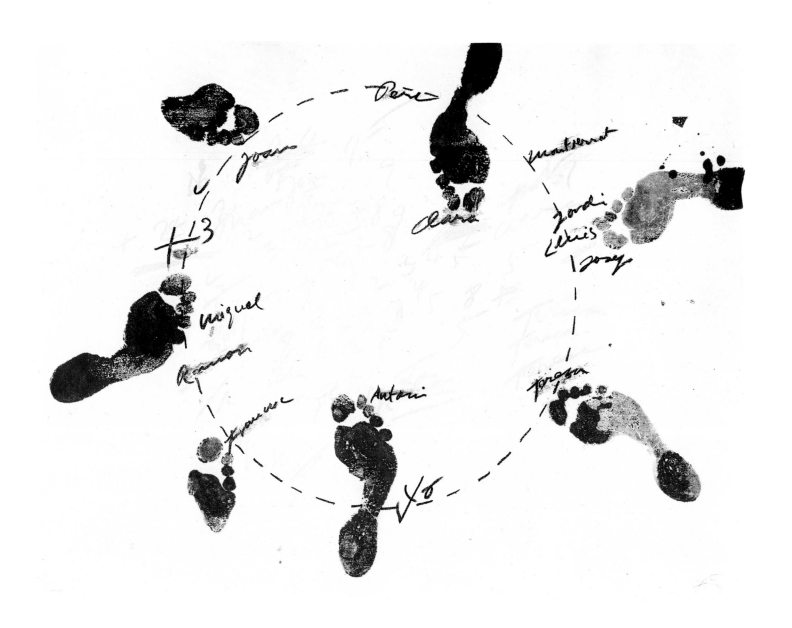

Pl. 32. Untitled, plate 2 from the *Suite Catalana*. 1972
Intaglio

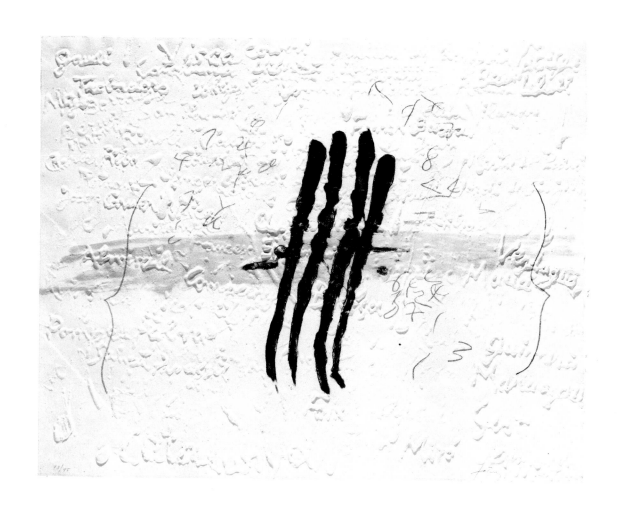

Pl. 33. *Quatre rius de sang.* 1972
Collagraph, intaglio, and carborundum

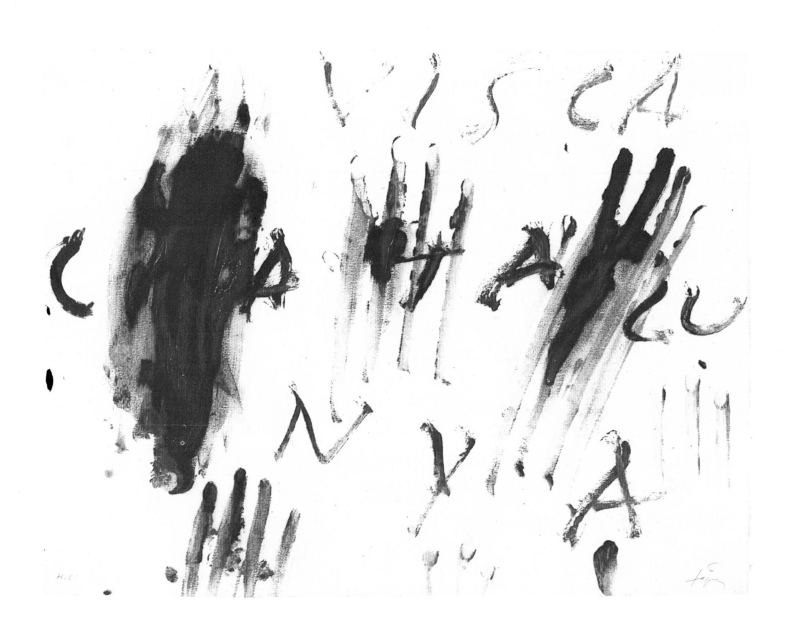

Pl. 34. *Visca Catalunya.* 1976
Intaglio and carborundum

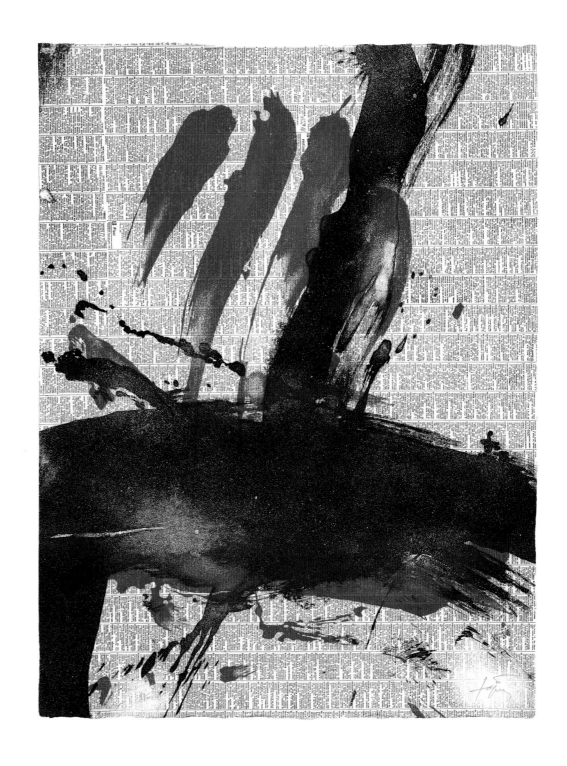

Pl. 35. *Ditades damunt diari*. 1975
Intaglio

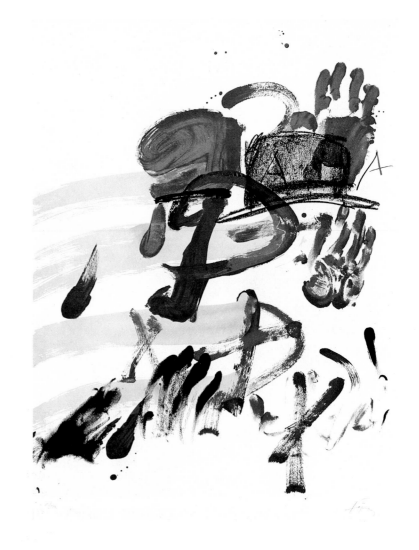

Pl. 36. Untitled, plate for the book
Homenatge a Joan Prats. 1975
Lithograph

Pl. 37. *4 Barres rouges*. 1972
Intaglio, carborundum, and collagraph

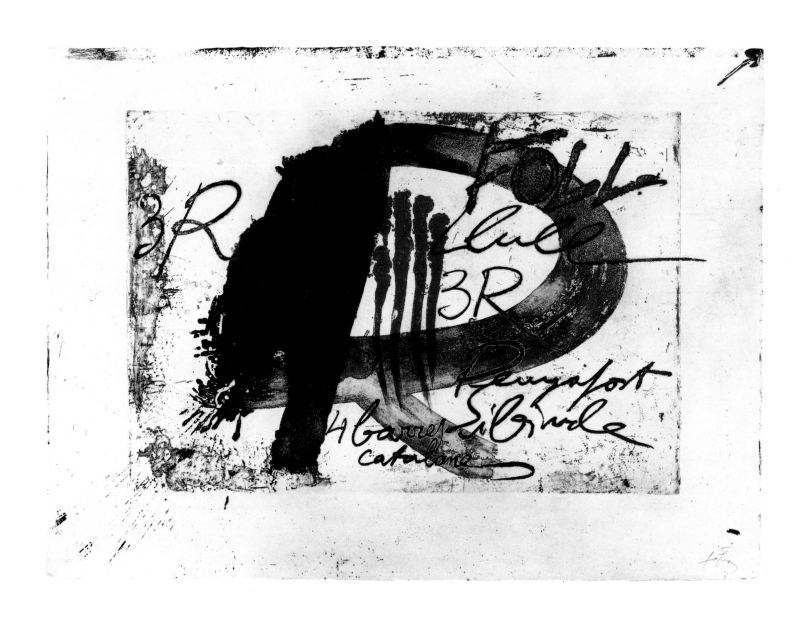

Pl. 38. *Tres R.* 1975
Intaglio

Pl. 39. Plate from *Llull-Tàpies*.
Texts by Ramon Llull. 1985
Intaglio with carborundum, collage, and lithograph

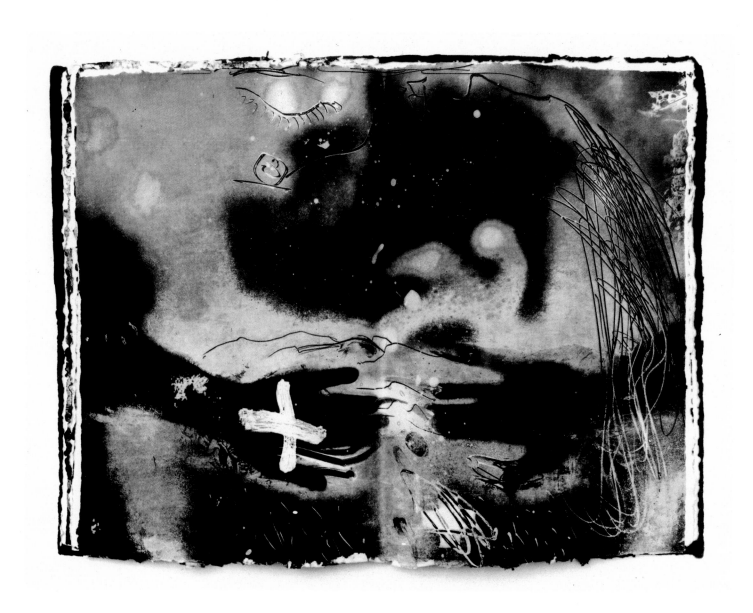

Pl. 40. Plate from *L'Estació* by J. V. Foix. 1984
Intaglio

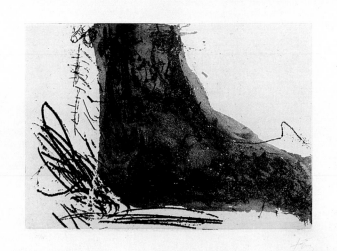

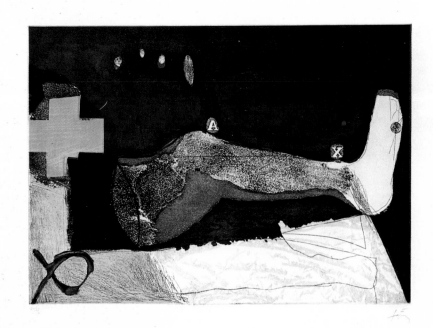

Pl. 41. *Le Pied*. 1969
Intaglio

Pl. 42. *La Cama*. 1975
Intaglio, collagraph, and carborundum

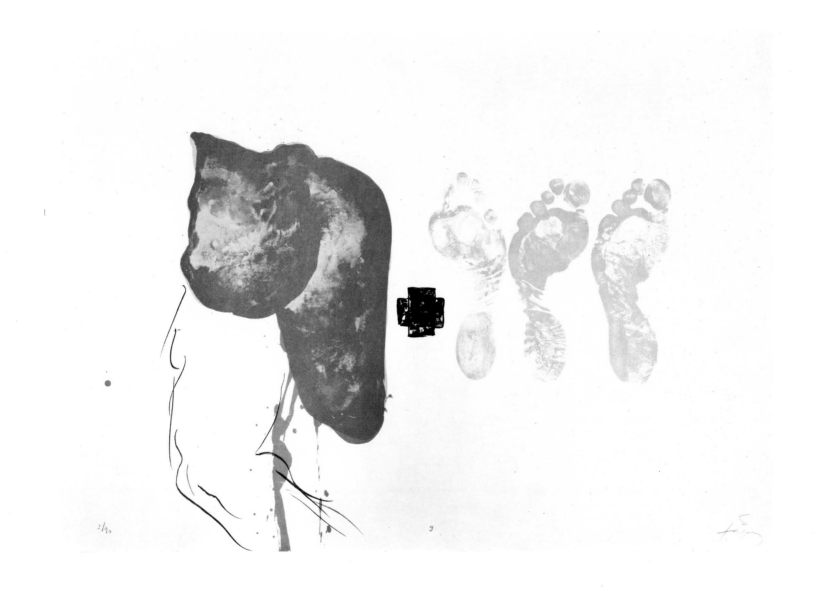

Pl. 43. Untitled from the series *Suite 63 x 90*. 1980
Lithograph

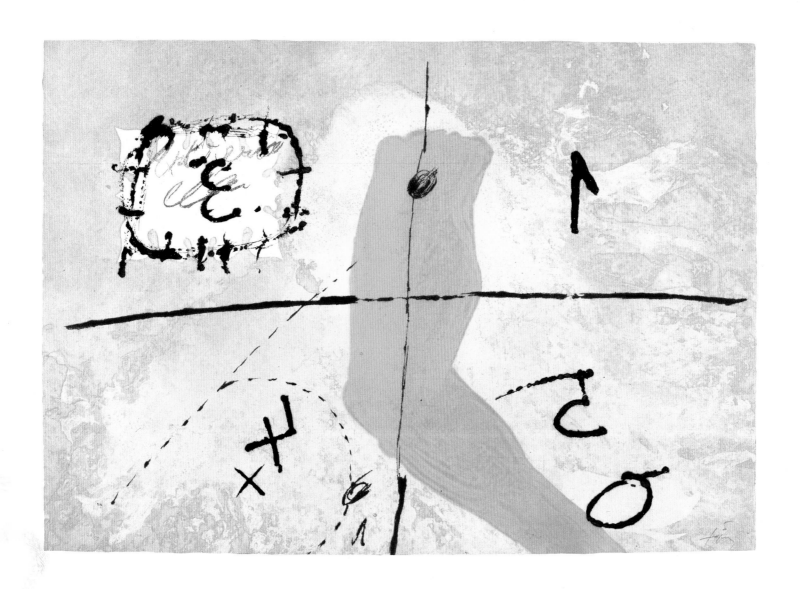

Pl. 44. *Signes et bras.* 1976
Intaglio and carborundum

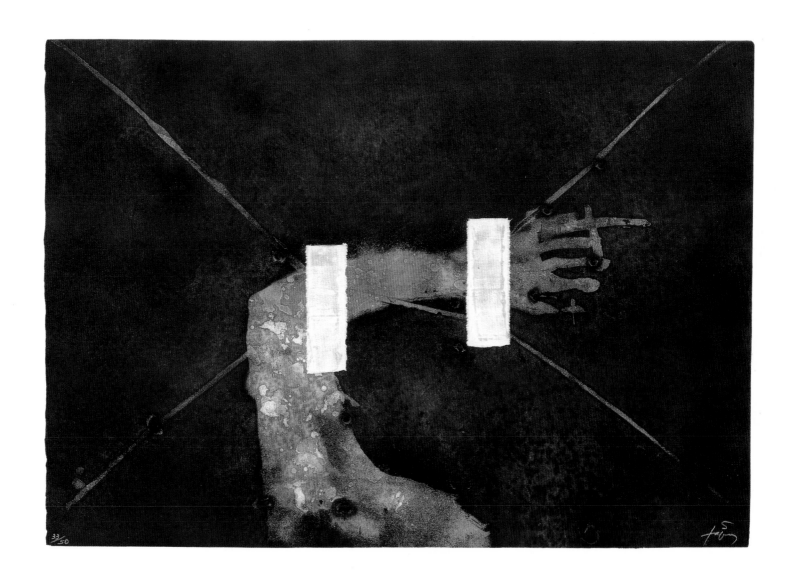

Pl. 45. *Empreinte.* 1984
Intaglio and carborundum with collage

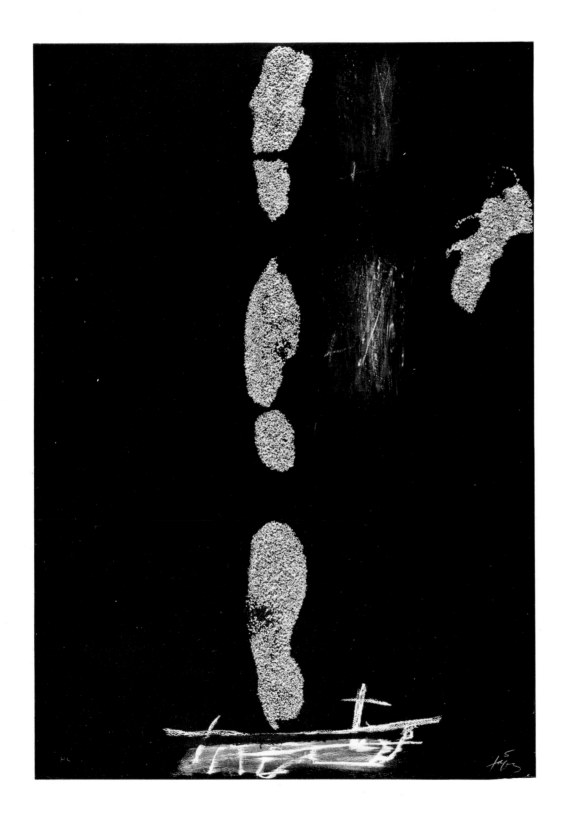

Pl. 46. *Empreintes de pas.* 1972
Lithograph with collage

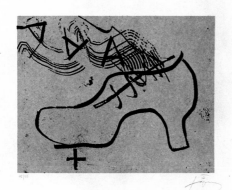

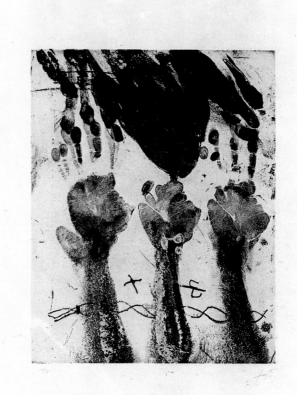

Pl. 47. *Sabata*. 1989
Intaglio on *papier appliqué*

Pl. 48. *Empreintes de mains*. 1969
Intaglio and carborundum

Pl. 49. Untitled from the series
Cartes per a la Teresa. 1974
Lithograph with collage

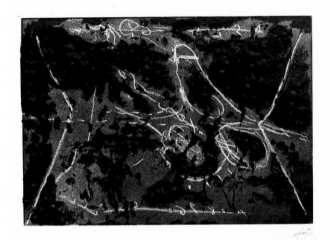

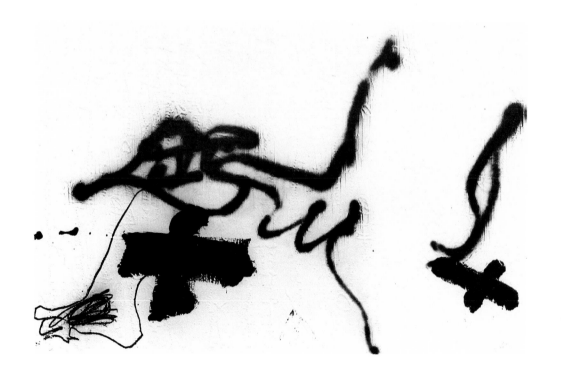

Pl. 50. *Matière et graffiti*. 1969
Intaglio and carborundum

Pl. 51. No. 12 from the series
Variations sur un thème musical. 1987
Lithograph and collagraph

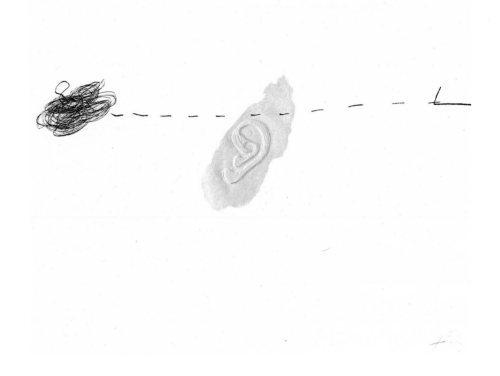

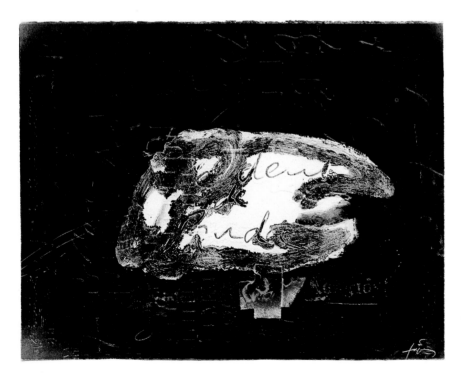

Pl. 52. *Orella.* 1972
Carborundum, intaglio, and collagraph
with hand additions

Pl. 53. No. 10 from the series
Variations sur un thème musical. 1987
Lithograph and collagraph with varnish

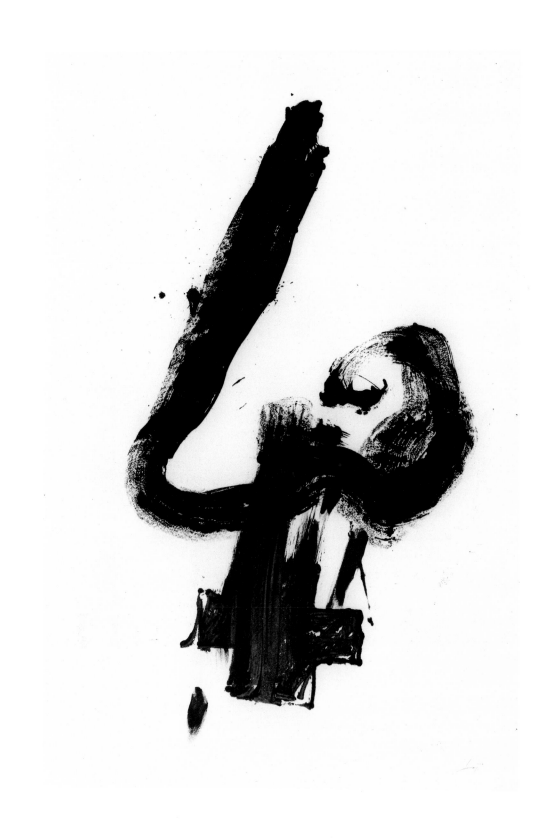

Pl. 54. *Grand Nez.* 1984
Lithograph

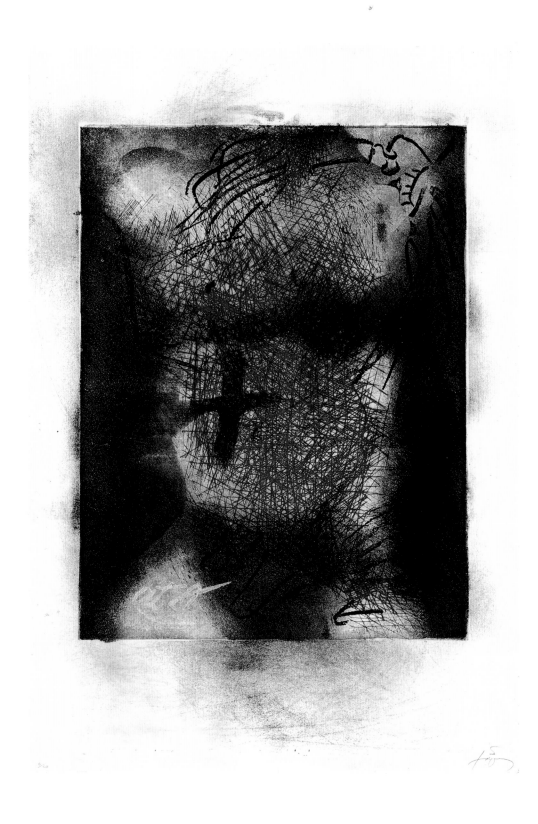

Pl. 55. *Tors*. 1988
Intaglio

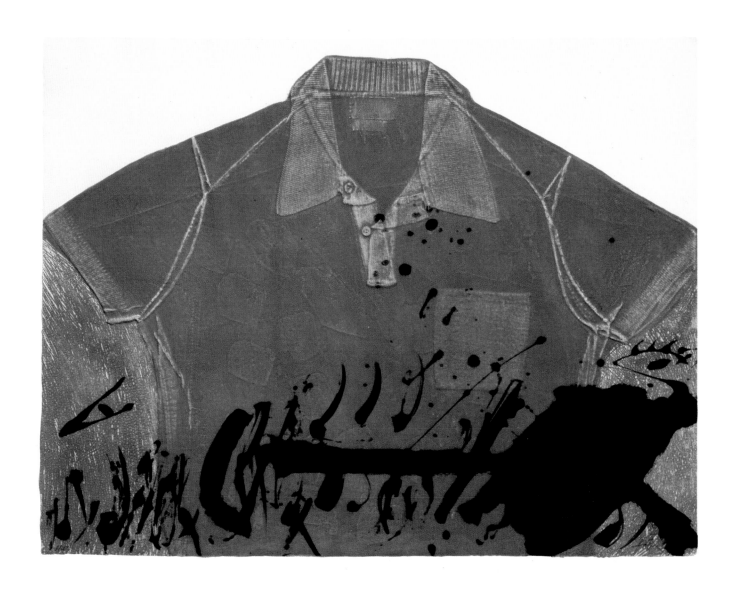

Pl. 56. *Camisa*. 1972
Carborundum, collagraph, and intaglio
with hand additions

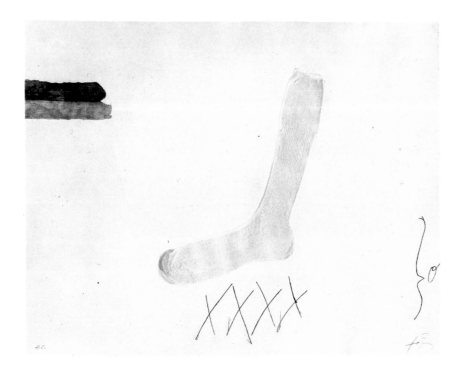

Pl. 57. *Mouchoir*. 1971
Carborundum, intaglio, and
collagraph with hand additions

Pl. 58. *Mitjó*. 1972
Intaglio, collagraph, and carborundum

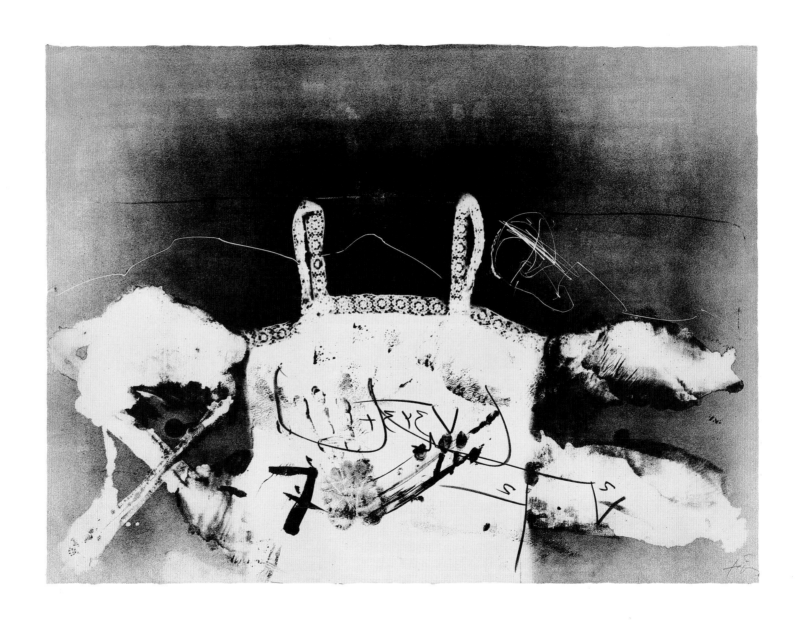

Pl. 59. *Dentelle*. 1977
Lithograph

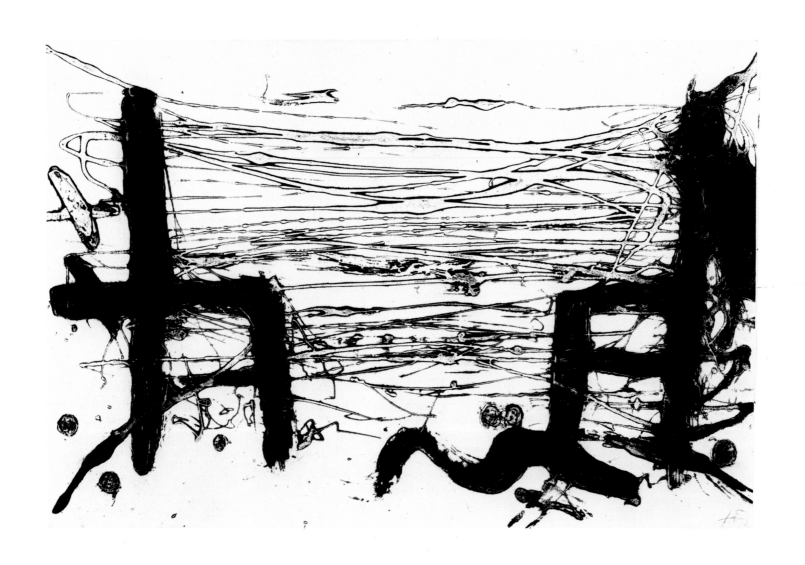

Pl. 60. *Chaises*. 1981
Carborundum

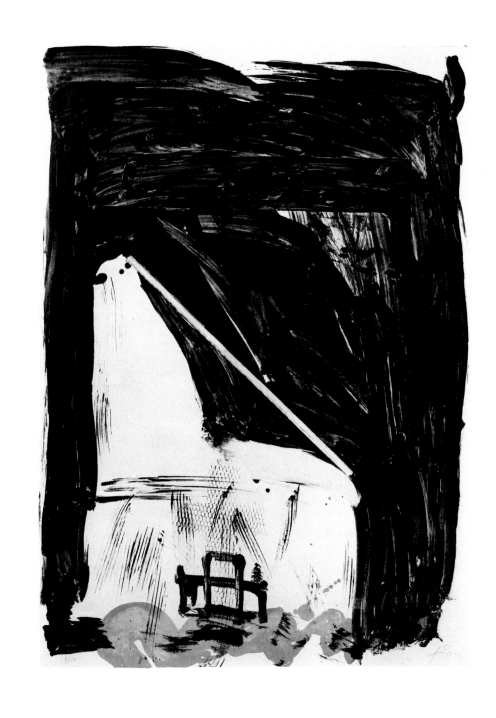

Pl. 61. *Grande Chaise*. 1984
Lithograph

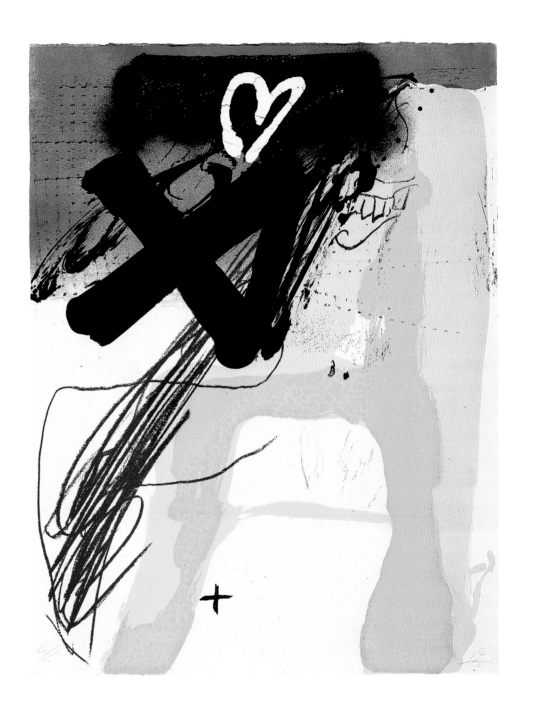

Pl. 62. *Vernís cadira*. 1981
Lithograph and screenprint with varnish

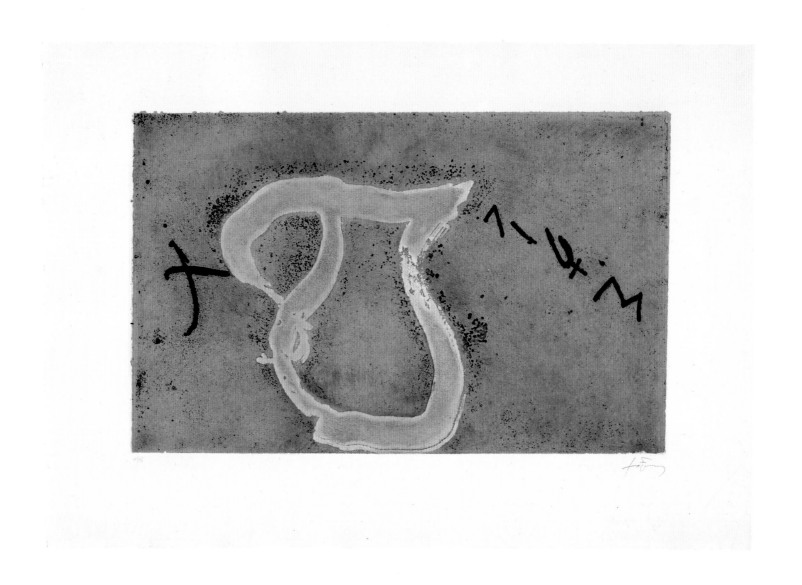

Pl. 63. *Gerra*. 1989
Intaglio and collagraph on *papier appliqué*

Pl. 64. *Les Ciseaux*. 1969
Collagraph and intaglio

Pl. 65. *Cercle de corde*. 1969
Collagraph

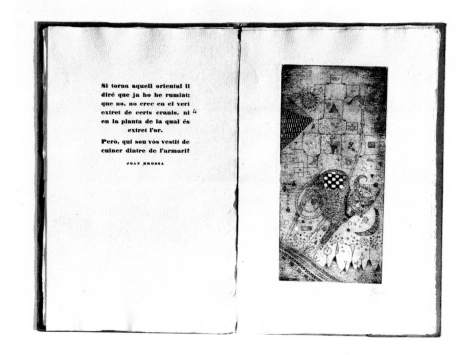

Pl. 66. Plate from *Dau al set*.
July/August/September 1949
Line block

Pl. 67. Plate from *Tres aiguaforts* by Joan Brossa. 1949
Intaglios inked as monotypes with hand additions

Pl. 68. Plate from *El pà a la barca*
by Joan Brossa. 1963
Lithograph

Pl. 69. Plate from *Novel·la*
by Joan Brossa. 1965
Lithograph

Pl. 70. Cover and plates from *Χ »*
by Jean Daive. 1975
Cover reproduction after drawing,
one intaglio with carborundum
and one collagraph with intaglio

Pl. 71. Plate from *Petrificada petrificante*
by Octavio Paz. 1978
Intaglio with carborundum
and varnish additions

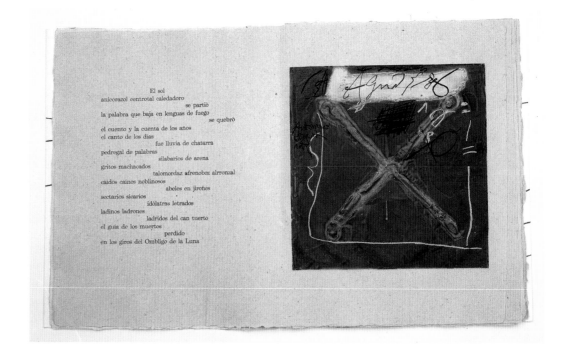

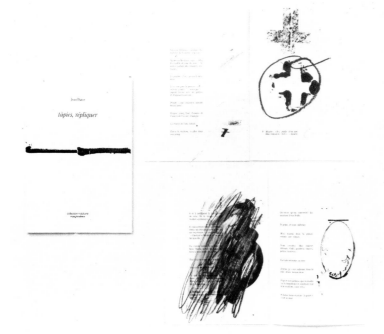

Pl. 72. Cover and plates from
Ça Suit son cours by Edmond Jabès. 1975
Collagraph and intaglio

Pl. 73. Cover and plates from
Tàpies, répliquer by Jean Daive. 1981
Reproductions after drawings

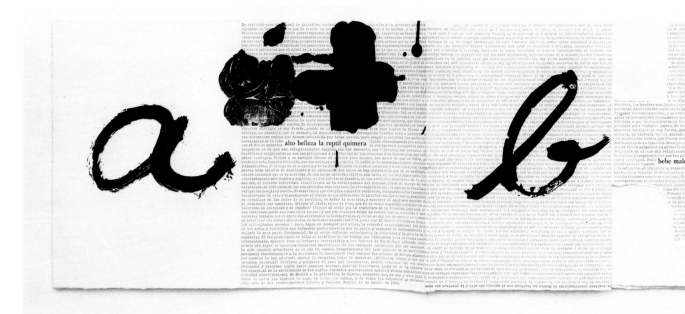

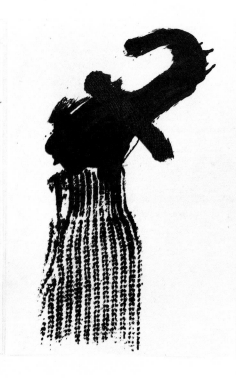

Pl. 74. Plates from *Anular*
by José Miguel Ullán. 1981
Intaglio

Pl. 75. Plate from *Llambrec material*
by Shuzo Takiguchi. 1975
Lithograph

List of Plates

Dates enclosed in parentheses do not appear on the works. Dimensions are given in inches and centimeters, height preceding width. Catalog (Galfetti) numbers refer to Mariuccia Galfetti's *Tàpies: Obra gràfica/Graphic Work 1947–1972* and *Tàpies: Obra gràfica/Graphic Work 1973–1978* (Barcelona: Editorial Gustavo Gili, 1973 and 1980). Translations for foreign-language titles are provided only for prints, not for literary works.

1. Untitled. Barcelona, Sala Gaspar, (1959). Lithograph, printed in black, composition: $35^1/2$ x $24^7/8$ in. (90 x 63 cm); sheet: $41^1/2$ x $29^1/2$ in. (105 x 75 cm). Edition: 50. Printer: Damià Caus at Foto-Repro, Barcelona. Lender: The Museum of Modern Art, New York. Gift of Mr. and Mrs. Armand P. Bartos. Galfetti 23.

2. *Espiral [Spiral]*. Barcelona, Edicions T, (1989). Intaglio, collagraph, and screenprint, printed in color, composition (sl. irreg.): $16^5/8$ x $26^7/8$ in. (42.3 x 68.3 cm); sheet: $24^5/8$ x $35^{11}/16$ in. (62.5 x 90.6 cm). Edition: 45. Printer: Magí Baleta, Barcelona. Lender: Galerie Lelong, New York.

3. *La Paille [Straw]*. Paris, Maeght Éditeur, (1969). Intaglio, printed in color on *papier appliqué*, with collage, plate: $13^7/8$ x $19^3/4$ in. (35.2 x 50.2 cm); sheet: $23^1/16$ x $30^9/16$ in. (58.6 x 77.6 cm). Edition: 75. Printer: Robert Dutrou at Arte, Adrien Maeght, Paris. Lender: Galerie Adrien Maeght, Paris. Galfetti 195.

4. *Le Crin [Horsehair]*. Paris, Maeght Éditeur, (1971). Intaglio and collagraph, printed in color, with collage, composition (irreg.): $30^{13}/16$ x $25^1/8$ in. (78.2 x 63.8 cm); sheet: $35^1/2$ x $25^1/8$ in. (90.1 x 63.8 cm). Edition: 75. Printer: Robert Dutrou at Arte, Adrien Maeght, Paris. Lender: The Museum of Modern Art, New York. Anonymous gift. Galfetti 274.

5. Untitled. Barcelona, Sala Gaspar, (1962). Lithograph and collagraph, printed in color, with flocking, composition (irreg.): $20^{11}/16$ x $22^3/16$ in. (52.6 x 56.4 cm); sheet: $22^1/16$ x 30 in. (56 x 76.2 cm). Edition: 50. Printer: Damià Caus at Foto-Repro, Barcelona. Lender: David Anderson Gallery, Buffalo, New York. Galfetti 43.

6. *Graphisme sobre paper [Strokes on Paper]*. Barcelona, Ediciones Polígrafa, (1972). Carborundum, printed in black on *papier appliqué*, composition (irreg.): 21 x $29^{13}/16$ in. (53.4 x 75.8 cm); sheet: 23 x $30^1/16$ in. (58.5 x 76.3 cm). Edition: 75. Printer: Torralba, Rubí and La Polígrafa, Barcelona. Lender: Galeria Joan Prats, New York. Galfetti 296.

7. *Graphismes et deux croix [Writing and Two Crosses]*. Paris, Maeght Éditeur, (1972). Intaglio and carborundum, printed in black, plate: $23^9/16$ x $38^{13}/16$ in. (59.8 x 98.6 cm); sheet: $31^9/16$ x $47^1/2$ in. (80.2 x 120.7 cm). Edition: 75. Printer: Robert Dutrou at Arte, Adrien Maeght, Paris. Lender: The Museum of Modern Art, New York. Anonymous gift. Galfetti 327.

8. *Pissarra [Blackboard]*. Barcelona, Ediciones Polígrafa, (1972). Carborundum and intaglio, printed in color, plate and sheet: $23^3/16$ x 30 in. (58.9 x 76.2 cm). Edition: 75. Printer: La Polígrafa, Barcelona. Lender: Galeria Joan Prats, New York. Galfetti 287.

9. *Oeuvre gravé [Printed Work]*. St. Gallen, Switzerland, Erker-Verlag, (1974). Lithograph, printed in color, composition (irreg.): $29^3/16$ x $19^{11}/16$ in. (74.1 x 50.0 cm); sheet: $35^5/8$ x $25^1/16$ in. (90.4 x 63.7 cm). Edition: 100. Printer: Erker-Presse, St. Gallen. (Accompanies special copies of the book *Tàpies: Das Graphische Werk/L'Oeuvre gravé 1947–1972*). Lender: Hans-Robert Thomas, Weiden, Germany. Galfetti 404.

10. Untitled, plate 7 from the *Berliner-Suite*. Berlin, Propyläen Verlag, (1974). Lithograph, printed in color, composition and sheet: $21^3/4$ x 30 in. (55.2 x 76.1 cm). Edition: 150. Printer: La Polígrafa, Barcelona. Lender: Galerie Lelong, New York. Galfetti 482.

11. *Z* from the series *U no és ningú* . Barcelona, Ediciones Polígrafa, (1979). Carborundum and intaglio, printed in color, composition (irreg.): $21^3/4$ x $28^5/16$ in. (55.3 x 72.8 cm); sheet: $21^{15}/16$ x $28^5/16$ in. (55.7 x 72.8 cm). Edition: 75. Printer: La Polígrafa, Barcelona. (The series accompanies the book *U no és ningú* by Joan Brossa). Lender: David Anderson Gallery, Buffalo, New York.

12. *Lletra O [Letter O]* from the series *Negre i roig [Black and Red]*. Barcelona, Ediciones Polígrafa, (1976). Intaglio, printed in color, with flocking, composition (irreg.): $20^1/2$ x $29^3/4$ in. (52.1 x 75.6 cm); sheet: $22^1/16$ x $29^3/4$ in. (56 x 75.6 cm). Edition: 75. Printer: La Polígrafa, Barcelona. Lender: Galeria Joan Prats, New York. Galfetti 620.

13. *Signic [Signifier]*. Paris, Maeght S.A., (1981). Intaglio and carborundum, printed in color, composition and sheet: $24^7/8$ x $35^{11}/16$ in. (63.1 x 90.6 cm). Edition: 50. Printer: Robert Dutrou at Atelier Morsang, Paris. Lender: Private Collection, New York.

14. *Fora [Go Away]* from the series *Negre i roig [Black and Red]*. Barcelona, Ediciones Polígrafa, (1976). Intaglio and carborundum, printed in color with flocking, composition (irreg.): $22^1/16$ x 28 in. (56 x 71.2 cm); sheet: $22^1/16$ x $29^7/8$ in. (56 x 75.8 cm). Edition: 75. Printer: La Polígrafa, Barcelona. Lender: David Anderson Gallery, Buffalo, New York. Galfetti 611.

15. *L'Echelle [Ladder]*. Paris, Maeght Éditeur, (1968). Lithograph, printed in color, composition and sheet: 56¼ x 41½ in. (142.9 x 105.4 cm). Edition: 75. Printer: René Lemoigne at Arte, Adrien Maeght, Paris. Lender: David Anderson Gallery, Buffalo, New York. Galfetti 160.

16. *Esperit Català I [Catalan Spirit I]*. Barcelona, Ediciones Polígrafa, (1974). Intaglio and collagraph, printed in color, plate: 17³/₁₆ x 24¹³/₁₆ in. (43.7 x 63 cm); sheet: 21⁷/₁₆ x 30¼ in. (54.5 x 76.8 cm). Edition: 75. Printer: La Polígrafa, Barcelona. Lender: Galeria Joan Prats, New York. Galfetti 391.

17. *A.T.* Paris, Maeght-Lelong, (1984). Lithograph, printed in color, composition: 15 x 22¹/₁₆ in. (38.1 x 56.1 cm); sheet: 23¹³/₁₆ x 30⁷/₈ in. (60.5 x 78.4 cm). Edition: 75. Printer: René Lemoigne at Atelier Lelong, Paris. Lender: Galerie Lelong, New York.

18. *X-A.* Paris, Maeght Éditeur, (1975). Intaglio, printed in color, composition and sheet: 24¹³/₁₆ x 35⁹/₁₆ in. (63 x 90.3 cm). Edition: 75. Printer: Robert Dutrou at Atelier Morsang, Paris. Lender: The Museum of Modern Art, New York. Anonymous gift. Galfetti 498.

19. *AT.* Barcelona, Ediciones Polígrafa, (1985). Intaglio, carborundum, and collagraph, printed in color, plate (irreg.) and sheet: 29³/₄ x 29⁵/₁₆ in. (75.5 x 74.5 cm). Edition: 99. Printer: La Polígrafa, Barcelona. Lender: Fundació Antoni Tàpies, Barcelona.

20. *Personnage assis [Seated Figure]* from the series *Variations*. St. Gallen, Switzerland, Erker-Verlag, (1984). Lithograph, printed in color, composition and sheet: 40⁷/₈ x 29¹/₈ in. (103.9 x 73.9 cm). Edition: 90. Printer: Erker-Presse, St. Gallen. Lender: Hans-Robert Thomas, Weiden, Germany.

21. *La Grande Porte [Large Door]*. Paris, Maeght Éditeur, (1972). Collagraph and carborundum, printed in color with collage and varnish, composition and sheet: 35¹/₂ x 26¹³/₁₆ in. (90.2 x 68.1 cm). Edition: 75. Printer: Robert Dutrou at Arte, Adrien Maeght, Paris. Lender: David Anderson Gallery, Buffalo, New York. Galfetti 323.

22. No. 1 from the series *Variations sur un thème musical [Variations on a Musical Theme]*. Paris, Lelong, (1987). Lithograph and collagraph, printed in black and gray, composition (irreg.) and sheet: 21¹/₈ x 27⁵/₈ in. (53.6 x 70.2 cm). Edition: 75. Printer: Damià Caus at Litografías Artísticas, Barcelona. Lender: The Museum of Modern Art, New York. Gift of Galerie Lelong, New York.

23. *X de vernís [Varnish X]* from the portfolio *El artista en la calle [The Artist in the Street]*. Valencia, *La calle*, (1982). Screenprint, printed in color, composition (irreg.): 19⁵/₈ x 25¹/₁₆ in. (49.9 x 63.7 cm); sheet: 19⁵/₈ x 25³/₁₆ in. (49.9 x 63.9 cm). Edition: 100. Printer: Ibero-Sulza,

S.L., Valencia. (*El artista en la calle* contains works by various artists). Lender: Fundació Antoni Tàpies, Barcelona.

24. *M 1/2.* Paris, Maeght-Lelong, (1984). Lithograph, printed in color, composition and sheet: 27¹/₂ x 39³/₁₆ in. (70 x 99.6 cm). Edition: 75. Printer: René Lemoigne at Atelier Lelong, Paris. Lender: Galerie Lelong, New York.

25. *Aparicions 2 [Apparitions 2]* from the suite *Aparicions*. Barcelona, Ediciones Polígrafa, (1982). Intaglio, collagraph, and carborundum, printed in color, composition (sl. irreg.): 16¹/₈ x 16¹/₄ in. (41 x 41.2 cm); sheet: 29¹⁵/₁₆ x 22³/₁₆ in. (76 x 56.4 cm). Edition: 99. Printer: La Polígrafa, Barcelona. (The suite accompanies the illustrated book *Aparicions* by Pere Gimferrer). Lender: David Anderson Gallery, Buffalo, New York.

26. *Petit t [Small t]*. Paris, Maeght-Lelong, (1984). Lithograph, printed in color, composition: 19⁹/₁₆ x 15⁵/₈ in. (49.7 x 39.7 cm); sheet: 27¹/₈ x 21⁵/₁₆ in. (68.9 x 54.1 cm). Edition: 75. Printer: René Lemoigne at Atelier Lelong, Paris. Lender: Fundació Antoni Tàpies, Barcelona.

27. *Vertical*. Paris, Maeght-Lelong, (1984). Intaglio, printed in color, plate: 42⁵/₈ x 13¹¹/₁₆ in. (108.2 x 34.7 cm); sheet: 47³/₄ x 15¹³/₁₆ in. (121.3 x 40.1 cm). Edition: 50. Printer: Robert Dutrou at Atelier Morsang, Paris. Lender: Fundació Antoni Tàpies, Barcelona.

28. *En Forme de montagne [Mountain Shape]*. Paris, Maeght Éditeur, (1980). Lithograph, printed in color, composition (irreg.): 14⁷/₁₆ x 21⁵/₁₆ in. (36.7 x 54.2 cm); sheet: 22¹/₄ x 30¹/₈ in. (56.5 x 76.5 cm). Edition: 75. Printer: René Lemoigne at Atelier Maeght, Paris. Lender: Private Collection, New York.

29. No. 17 from the series *Variations sur un thème musical [Variations on a Musical Theme]*. Paris, Lelong, (1987). Collagraph and lithograph, printed in black, composition and sheet: 21⁷/₁₆ x 27⁹/₁₆ in. (54.4 x 70 cm). Edition: 75. Printer: Damià Caus at Litografías Artísticas, Barcelona. Lender: Galerie Lelong, New York.

30. *Cadira [Chair]*. Barcelona, Edicions T, (1990). Intaglio, printed in brown black on monotype, composition and sheet: 76⁷/₈ x 37⁷/₈ in. (195.0 x 96.3 cm). Edition: 30. Printer: Takeshi Motomiya and Joan Roma at Taller Nou, Barcelona. Lender: Fundació Antoni Tàpies, Barcelona.

31. Untitled, plate 1 from the *Suite Catalana*. Barcelona, Editorial Gustavo Gili, (1972). Intaglio, printed in color, plate (irreg.) and sheet: 29⁷/₈ x 39¹¹/₁₆ in. (75.8 x 100.9 cm). Edition: 75. Printer: Joan Barbarà, Barcelona. Lender: David Anderson Gallery, Buffalo, New York. Galfetti 302.

32. Untitled, plate 2 from the *Suite Catalana*. Barcelona, Editorial Gustavo Gili, (1972). Intaglio, printed in color, composition (irreg.): 28³/₄ x 39⁵/₈ in. (73.1 x 100.7 cm); sheet: 30 x 39¹⁵/₁₆ in. (76.2 x 101.5 cm). Edition: 75. Printer: Joan Barbarà, Barcelona. Lender: David Anderson Gallery, Buffalo, New York. Galfetti 303.

33. *Quatre rius de sang [Four Rivers of Blood]*. Barcelona, Ediciones Polígrafa, (1972). Collagraph, intaglio, and carborundum, printed in color, composition (irreg.) and sheet: 23¹/₈ x 30¹/₁₆ in. (58.7 x 76.4 cm). Edition: 75. Printer: Torralba, Rubí and La Polígrafa, Barcelona. Lender: David Anderson Gallery, Buffalo, New York. Galfetti 291.

34. *Visca Catalunya [Long Live Catalonia]* from the series *Negre i roig [Black and Red]*. Barcelona, Ediciones Polígrafa, (1976). Intaglio and carborundum, printed in color, composition (irreg.) and sheet: 22¹/₄ x 29⁷/₁₆ in. (56.5 x 74.8 cm). Edition: 75. Printer: La Polígrafa, Barcelona. Lender: Galeria Joan Prats, New York. Galfetti 618.

35. *Ditades damunt diari [Fingerprints on Newspaper]*. Palma de Mallorca (Spain), Sala Pelaires, (1975). Intaglio, printed in color, plate and sheet: 25¹³/₁₆ x 19³/₄ in. (65.5 x 50.2 cm). Edition: 100. Printer: Joan Barbarà, Barcelona. Lender: Fundació Antoni Tàpies, Barcelona. Galfetti 505.

36. Untitled, plate for the book *Homenatge a Joan Prats*. Barcelona, Fundació Miró, C.E.A.C., (1975). Lithograph, printed in color, composition: (irreg.): 28¹/₈ x 21⁵/₈ in. (71.4 x 55 cm); sheet: 29¹³/₁₆ x 21¹⁵/₁₆ in. 75.7 x 55.7 cm). Edition: 100. Printer: La Polígrafa, Barcelona. (*Homenatge a Joan Prats* contains texts and lithographs by various authors and artists.) Lender: Galeria Joan Prats, New York. Galfetti 538.

37. *4 Barres rouges [Four Red Strokes]*. Paris, Maeght Éditeur, (1972). Intaglio, carborundum, and collagraph, printed in color, composition (sl. irreg.): 22⁵/₈ x 12³/₁₆ in. (57.4 x 31 cm); sheet: 35³/₄ x 24¹⁵/₁₆ in. (90.8 x 63.4 cm). Edition: 75. Printer: Robert Dutrou at Arte, Adrien Maeght, Paris. Lender: Private Collection, New York. Galfetti 326.

38. *Tres R [Three R's]*. Barcelona, Fundación Picasso-Reventós, (1975). Intaglio, printed in color, plate (irreg.) and sheet: 25¹/₈ x 35¹/₂ in. (63.8 x 90.1 cm). Edition: 75. Printer: Joan Barbarà, Barcelona. Lender: Fundació Antoni Tàpies, Barcelona. Galfetti 504.

39. *Llull-Tàpies*. Texts by Ramon Llull and contributions by Miquel Batllori and Pere Gimferrer. Paris and Barcelona, Daniel Lelong and Carles Taché, 1985. Twenty-four intaglios (most with carborundum, collagraph, flocking, collage and/or die cut) and one collagraph, carborundum, and intaglio, printed in color; and one collagraph (wrapper) housed in a burlap box with design by the artist. Page: 14¹/₁₆ x 19¹¹/₁₆ in. (35.8 x 50 cm). Edition: 165. Printer: Joan Barbarà,

Barcelona. Lender: The Museum of Modern Art, New York. Gift of Galerie Lelong, New York.

40. *L'Estació* by J. V. Foix. Barcelona, Carles Taché, 1984. Five intaglios (including wrapper) housed in a linen box with design by the artist, page: (sl. irreg.): 22¹/₄ x 15¹/₁₆ in. (56.5 x 38.3 cm). Edition: 100. Printer: Joan Barbarà, Barcelona. Lender: Fundació Antoni Tàpies, Barcelona.

41. *Le Pied [Foot]*. Paris, Maeght Éditeur, (1969). Intaglio, printed in color, plate: 13⁷/₈ x 19¹³/₁₆ in. (35.2 x 50.3 cm); sheet: 22⁵/₈ x 30¹/₂ in. (57.4 x 77.5 cm). Edition: 75. Printer: Robert Dutrou at Arte, Adrien Maeght, Paris. Lender: The Museum of Modern Art, New York. Anonymous gift. Galfetti 204.

42. *La Cama [Leg]*. Barcelona, Ediciones Polígrafa (1975). Intaglio, collagraph, and carborundum, printed in color, plate: 17⁵/₁₆ x 24¹³/₁₆ in. (44 x 63 cm); sheet: 22¹/₁₆ x 30³/₈ in. (56.1 x 77.2 cm). Edition: 75. Printer: La Polígrafa, Barcelona. Lender: David Anderson Gallery, Buffalo, New York. Galfetti 510.

43. Untitled from the series *Suite 65 x 90*. St. Gallen, Switzerland, Erker-Verlag, (1980). Lithograph, printed in color, composition (irreg): 21¹/₈ x 27¹⁵/₁₆ in. (53.7 x 71.0 cm); sheet: 24⁵/₈ x 35¹/₂ in. (62.5 x 90.1 cm). Edition: 90. Printer: Erker-Presse, St. Gallen. Lender: Hans-Robert Thomas, Weiden, Germany.

44. *Signes et bras [Signs and Arm]*. Barcelona, Galería Maeght, (1976). Intaglio and carborundum, printed in color, plate and sheet: 24⁷/₈ x 35¹⁵/₁₆ in. (63.2 x 91.2 cm). Edition: 50. Printer: Joan Barbarà, Barcelona. Lender: Galerie Adrien Maeght, Paris. Galfetti 597.

45. *Empreinte [Imprint]*. Paris, Maeght-Lelong, (1984). Intaglio and carborundum, printed in color with collage, composition and sheet: 24¹³/₁₆ x 35¹³/₁₆ in. (63 x 91 cm). Edition: 50. Printer: Robert Dutrou at Atelier Morsang, Paris. Lender: Galerie Lelong, New York.

46. *Empreintes de pas [Footprints]*. Paris, Maeght Éditeur, (1972). Lithograph, printed in color, with collage, composition and sheet: 35³/₄ x 24⁷/₈ in. (90.8 x 63.2 cm). Edition: 75. Printer: René Lemoigne at Arte, Adrien Maeght, Paris. Lender: Galerie Adrien Maeght, Paris. Galfetti 341.

47. *Sabata [Shoe]*. Barcelona, Edicions T, (1989). Intaglio, printed in black on *papier appliqué*, plate: 9³/₄ x 12¹¹/₁₆ in. (24.8 x 32.2 cm); sheet: 19⁹/₁₆ x 25³/₄ in. (49.7 x 65.4 cm). Edition: 45. Printer: Takeshi Motomiya and Joan Roma at Taller Nou, Barcelona. Lender: Galerie Lelong, New York.

48. *Empreintes de mains [Handprints]*. Paris, Maeght Éditeur, (1969). Intaglio and carborundum, printed in color, plate: 19⁹/₁₆ x 15¹/₂ in. (49.7 x 39.4 cm); sheet: 30¹/₂ x 23¹/₈ in. (77.5 x 58.7 cm). Edition: 75. Printer: Robert Dutrou at Arte, Adrien Maeght, Paris. Lender: The Museum of Modern Art, New York. Donald Karshan Fund. Galfetti 230.

49. Untitled from the series *Cartes per a la Teresa [Letters to Teresa]*. Paris, Maeght Éditeur, (1974). Lithograph, printed in color with collage, composition (irreg.): 30⁵/₁₆ x 24³/₄ in. (77 x 62.8 cm); sheet: 30⁵/₁₆ x 24¹³/₁₆ in. (77 x 63 cm). Edition: 150. Printer: René Lemoigne at Arte, Adrien Maeght, Paris. Lender: Private Collection, New York. Galfetti 416.

50. *Matière et graffiti [Matter and Graffiti]*. Paris, Maeght Éditeur, (1969). Intaglio and carborundum, printed in black, plate 13⁷/₈ x 19⁷/₈ in. (35.2 x 50.5 cm); sheet: 22¹¹/₁₆ x 30¹/₂ in. (57.6 x 77.5 cm). Edition: 75. Printer: Robert Dutrou at Arte, Adrien Maeght, Paris. Lender: The Museum of Modern Art, New York. Anonymous gift. Galfetti 191.

51. No. 12 from the series *Variations sur un thème musical [Variations on a Musical Theme]*. Paris, Lelong, (1987). Lithograph and collagraph, composition (irreg.) and sheet: 25¹/₂ x 39⁵/₁₆ in. (64.8 x 99.9 cm). Edition: 75. Printer: Damià Caus at Litografías Artísticas, Barcelona. Lender: The Museum of Modern Art, New York. Gift of Galerie Lelong, New York.

52. *Orella [Ear]*. Barcelona, Ediciones Polígrafa, (1972). Carborundum, intaglio, and collagraph, printed in color, with hand additions, composition (irreg.): 14³/₄ x 29³/₈ in. (37.5 x 74.6 cm); sheet: 23¹/₁₆ x 30¹/₈ in. (58.6 x 76.5 cm). Edition: 75. Printer: La Polígrafa, Barcelona. Lender: Galeria Joan Prats, New York. Galfetti 297.

53. No. 10 from the series *Variations sur un thème musical [Variations on a Musical Theme]*. Paris, Lelong, (1987). Lithograph and collagraph, printed in color, with varnish, composition and sheet: 21³/₁₆ x 27¹/₂ in. (53.8 x 70 cm). Edition: 75. Printer: Damià Caus at Litografías Artísticas, Barcelona. Lender: Galerie Lelong, New York.

54. *Grand Nez [Large Nose]*. Paris, Maeght-Lelong, (1984). Lithograph, printed in color, composition (irreg.): 41⁷/₁₆ x 23⁹/₁₆ in. (105.2 x 59.8 cm); sheet: 47 x 31⁷/₁₆ in. (119.4 x 79.9 cm). Edition: 75. Printer: René Lemoigne at Atelier Lelong, Paris. (Exhibition poster for "Tàpies," Galerie Maeght-Lelong, Paris, reproduced this image.) Lender: The Museum of Modern Art, New York. Gift of Galerie Lelong, New York.

55. *Tors [Torso]*. Vaduz, Lichtenstein, Grafos Verlag, (1988). Intaglio, printed in color, composition (irreg.) and sheet: 35⁵/₈ x 24¹¹/₁₆ in. (90.4 x 62.7 cm). Edition: 60. Printer: Joan Barbarà, Barcelona. Lender: Grafos Verlag, Vaduz.

56. *Camisa [Shirt]*. Barcelona, Ediciones Polígrafa, (1972). Carborundum, collagraph, and intaglio, printed in color with hand additions, composition (irreg.): 22³/₈ x 30⁵/₈ in. (56.8 x 77.8 cm); sheet: 22¹⁵/₁₆ x 30⁵/₈ in. (58.3 x 77.8 cm). Edition: 75. Printer: La Polígrafa, Barcelona. Lender: David Anderson Gallery, Buffalo, New York. Galfetti 301.

57. *Mouchoir [Handkerchief]*. Barcelona, Ediciones Polígrafa, (1971). Carborundum, intaglio, and collagraph, printed in color with hand additions, plate: 19¹/₂ x 25⁵/₈ in. (49.5 x 65 cm); sheet: 24³/₄ x 30¹/₄ in. (62.8 x 76.8 cm). Edition: 100. Printer: La Polígrafa, Barcelona. (Accompanies special copies of the French edition of Cirici Pellicer's *Tàpies, Testimoni del silenci*). Lender: Galeria Joan Prats, New York. Galfetti 251.

58. *Mitjó [Sock]*. Barcelona, Ediciones Polígrafa, (1972). Intaglio, collagraph, and carborundum, printed in color, composition (irreg.): 22¹/₄ x 30 in. (56.5 x 76.2 cm); sheet 23¹/₁₆ x 30 in. (58.6 x 76.2 cm). Edition: 75. Printer: La Polígrafa, Barcelona. Lender: Galeria Joan Prats, New York. Galfetti 292.

59. *Dentelle [Lace]*. St. Gallen, Switzerland, Erker-Verlag, (1977). Lithograph, printed in color, composition (sl. irreg.) and sheet: 29¹/₂ x 39¹³/₁₆ in. (74.3 x 101.2 cm). Edition: 150. Printer: Erker-Presse, St. Gallen. (Created as the annual edition of the Kunstverein für die Rheinlande und Westfalen, Düsseldorf.) Lender: Hans-Robert Thomas, Weiden, Germany. Galfetti 662.

60. *Chaises [Chairs]*. Paris, Maeght S.A., (1981). Carborundum, printed in brown black, composition (irreg.): 36¹/₄ x 54³/₄ in. (92 x 139 cm); sheet: 36⁵/₈ x 54³/₄ in. (93.1 x 139 cm). Edition: 30. Printer: Robert Dutrou at Atelier Morsang, Paris. Lender: The Musuem of Modern Art, New York. Anonymous gift.

61. *Grande Chaise [Large Chair]* from the series *Variations*. St. Gallen, Switzerland, Erker-Verlag, (1984). Lithograph, printed in color, composition (sl. irreg.): 40⁹/₁₆ x 28⁹/₁₆ in. (103 x 72.6 cm); sheet: 40⁵/₈ x 28¹³/₁₆ in. (103.2 x 73.2 cm). Edition: 90. Printer: Erker-Presse, St. Gallen. Lender: Hans-Robert Thomas, Weiden, Germany.

62. *Vernís cadira [Varnish Chair]*. Madrid, Galeria Nieves Fernandez, (1981). Lithograph and screenprint, printed in color with varnish, plate (irreg.) and sheet: 26 x 19¹⁵/₁₆ in. (66.1 x 50.6 cm). Edition: 75. Printer: Taller Vallirana, Barcelona. Lender: Fundació Antoni Tàpies, Barcelona.

63. *Gerra [Pitcher]*. Barcelona, Edicions T, (1989). Intaglio and collagraph, printed in color on *papier appliqué*, composition (sl. irreg.): 16⁹/₁₆ x 27 in. (42.1 x 68.6 cm); sheet: 24⁵/₁₆ x 35¹³/₁₆ in. (62.6 x 91 cm). Edition: 45. Printer: Magí Baleta, Barcelona. Lender: Galerie Lelong, New York.

64. *Les Ciseaux [Scissors]*. Paris, Maeght Éditeur, (1969). Collagraph and intaglio, printed in color, plate: 19³/₄ x 13³/₄ in. (50.1 x 35 cm); sheet: 30 x 22¹¹/₁₆ in. (76.2 x 58 cm). Edition: 75. Printer: Robert Dutrou at Arte, Adrien Maeght, Paris. Lender: David Anderson Gallery, Buffalo, New York. Galfetti 193.

65. *Cercle de corde [Circle of Rope]*. Paris, Maeght Éditeur, (1969). Collagraph, plate (irreg.): 13³/₄ x 19¹¹/₁₆ in. (35 x 50.6 cm); sheet: 22⁷/₈ x 30⁵/₈ in. (58.1 x 77.7 cm). Edition: 75. Printer: Robert Dutrou at Arte, Adrien Maeght, Paris. Lender: David Anderson Gallery, Buffalo, New York. Galfetti 196.

66. *Dau al set*. Barcelona, July/August/September 1949. Line block reproductions after drawings, page: 9⁷/₈ x 6³/₄ in. (25 x 17.1 cm). Lender: The Museum of Modern Art Library, New York.

67. *Tres aiguaforts* by Joan Brossa. Barcelona, Enric Tormo, (1949). Three intaglios, inked as monotypes with hand additions, page: 13¹/₁₆ x 8⁷/₈ in. (33.5 x 22.6 cm). Edition: 7. Printer: Enric Tormo, Barcelona. Lender: Fundació Antoni Tàpies, Barcelona. Galfetti 10–12.

68. *El pà a la barca* by Joan Brossa. Barcelona, Sala Gaspar, 1963. Twenty-two lithographs (including wrapper) and four collages, two with line block printed in color; housed in a vellum cover, page (irreg.): 15¹/₄ x 10¹⁵/₁₆ in. (38.7 x 27.8 cm). Edition: 135. Printer: Damià Caus at Foto-Repro, Barcelona. Lender: The Museum of Modern Art, New York. Monroe Wheeler Fund. Galfetti 48–72.

69. *Novel·la* by Joan Brossa. Barcelona, Sala Gaspar, 1965. Thirty-seven lithographs (some folded, cut out, and/or wrinkled), housed in linen cover with string ties designed by the artist, page: 15¹/₂ x 11¹/₄ in. (39.5 x 28.5 cm). Edition: 140. Printer: Damià Caus at Foto-Repro, Barcelona. Lender: Fundació Antoni Tàpies, Barcelona. Galfetti 85–121.

70. *X* by Jean Daive. Paris, Maeght Éditeur, 1975. Three intaglios (two with carborundum or collagraph) and two collagraphs with intaglio, printed in color; and reproductions after drawings (including wrapper), page: 9³/₈ x 7¹/₁₆ in. (23.8 x 18 cm). Edition 120. Printer: Robert Dutrou at Atelier Morsang, Paris. Lender: The Museum of Modern Art, New York. Anonymous gift. Galfetti 525–29.

71. *Petrificada petrificante* by Octavio Paz. Paris, Maeght Éditeur, 1978. Seven intaglios (some with carborundum, collagraph and/or varnish additions), printed in color, and one collagraph and intaglio (wrapper), housed in linen box with design by the artist, page (irreg.): 20¹/₂ x 16¹/₈ in. (52 x 41 cm). Edition: 175. Printer: Robert Dutrou at Atelier Morsang, Paris. Lender: The Museum of Modern Art, New York. Mrs. Gilbert W. Chapman Fund and gift of Galerie Maeght. Galfetti 698–705.

72. *Ça Suit son cours* by Edmond Jabès. Montpellier, Fata Morgana, 1975. Four intaglios (two with collagraph), printed in color; reproductions after drawings and one collagraph and intaglio (wrapper) housed in a corrugated cardboard box with design by the artist, page: 10⁵/₈ x 6¹¹/₁₆ in. (27 x 17 cm). Edition: 102. Printer: Robert Dutrou at Atelier Morsang, Paris. Lender: Fundació Antoni Tàpies, Barcelona. Galfetti 520–24.

73. *Tàpies, répliquer* by Jean Daive. Paris, Maeght S.A., 1981. Four intaglios (three with carborundum and one with collagraph), printed in color; and reproductions after drawings (including wrapper), page (irreg.): 11¹/₄ x 8¹/₁₆ in. (28.5 x 20.5 cm). Edition: 200. Printer: Robert Dutrou at Atelier Morsang, Paris. Lender: The Museum of Modern Art, New York. Anonymous gift.

74. *Anular* by José Miguel Ullán. Paris, Éditions R.L.D. (Robert and Lydia Dutrou), 1981. Twenty-two intaglios (some with cut outs, two with collagraph and one with manipulated paper) and one intaglio and carborundum (wrapper), page: 12¹¹/₁₆ x 9¹/₂ in. (32.2 x 24.1 cm). Edition: 125. Printer: Robert Dutrou at Atelier Morsang, Paris. Lender: Fundació Antoni Tàpies, Barcelona.

75. *Llambrec material* by Shuzo Takiguchi. Barcelona, Ediciones Polígrafa, 1975. Twelve lithographs, printed in color; and one lithograph (wrapper) housed in cardboard cover and linen box with design by the artist, page: 17¹/₄ x 12³/₄ in. (44 x 32.5 cm). Edition: 266. Printer: La Polígrafa, Barcelona. Lender: Fundació Antoni Tàpies, Barcelona. Galfetti 539–56.

Chronology of Print-Related Activities

Only major print exhibitions and their catalogs are cited. Further biographical information is available in chronologies by Miquel Tàpies in the following references: Anna Agustí, *Tàpies: The Complete Works, Volume 1: 1943–1960* (New York: Rizzoli, 1988); Anna Agustí, *Tàpies: The Complete Works, Volume 2: 1961–1968* (New York: Rizzoli, 1990); and Lluís Permanyer, *Tàpies and the New Culture* (New York: Rizzoli, 1986).

1923
Born Barcelona, December 13.

1936–39
Spanish Civil War.

1947
Meets the Catalan poet and playwright Joan Brossa (b. 1919), with whom he will have a lifelong friendship and numerous artistic collaborations. Through Brossa meets the Catalan art patron Joan Prats (1891–1970), who will introduce him to Joan Miró.

Makes first prints (intaglios) at the studio of Barcelona printer Enric Tormo.

1948
With others founds art and literary journal *Dau al set*.

1949
Meets the Catalan poet J. V. Foix (1894–1987).

Collaborates with Joan Brossa on the album *Tres aiguaforts*, published by Enric Tormo, Barcelona, with three intaglios by Tàpies.

Collaborates with Joan Brossa on *Album T*, published by Enric Tormo, Barcelona, with six intaglios by Tàpies.

1952
Plays the part of Harlequin in Joan Brossa's theater piece *Night Encounters*.

1953
Contributes a frontispiece (intaglio) to the Catalan poet, critic, and scholar Carles Riba's (1893–1959) *Salvatge cor*, published by the University of Salamanca, Spain.

Begins long association with Martha Jackson Gallery, New York; visits New York.

1956
Begins long association with Galerie Stadler, Paris.

1958
Meets the French poet and art critic Jacques Dupin (b. 1927).

Meets the Japanese poet, critic, and painter Shuzo Takiguchi (1903–1970).

1959
Publishes first prints (lithographs) with Sala Gaspar, Barcelona.

1960
Creates a poster for the opening of the Museo de Arte Contemporáneo, Barcelona, the first of many he will produce for exhibitions, events, and causes.

Exhibits in Tokyo, "International Biennial Exhibition of Prints" (awarded prize).

1961
Designs set for Joan Brossa's *Or i sal*, performed at the Palau de la Musica Catalana, Barcelona.

1962
In St. Gallen, Switzerland, executes mural for the library in the new Handels-Hochschule, and meets Jürg Janett and Franz Larese, whom he will work with on his projects and exhibitions with Erker.

Designs covers (lithographs) for the illustrated book *Cop de poma*, published by RM, Barcelona, with contributions by Joan Brossa, Mestres Quadreny, Joan Miró, and Moisé Villèlia. (Will contribute prints to a variety of projects with which he is in sympathy, and in which he is one of several contributing artists.)

Creates a lithograph to be published by the Kunstverein (arts club) of St. Gallen. (Will create many prints for the benefit of such local arts associations.)

1963
Begins long association with Erker-Galerie, St. Gallen, Switzerland.

First print (lithograph) published by Erker-Verlag, St. Gallen was the "avant la lettre" version of the poster for his exhibition. Active publishing with Erker begins in 1965 with *Album St. Gallen*, a series of ten lithographs.

Collaborates with Joan Brossa on the illustrated book *El pà a la barca*, published by Sala Gaspar, Barcelona, with twenty-two lithographs and four collages by Tàpies.

1964
First print (intaglio) published by Polígrafa, Barcelona, to accompany preferred copies of a monograph on the artist; active publishing with Polígrafa begins in 1972. (Will create many prints to accompany monographs and catalogs, or to serve as covers.)

Creates a lithograph, published by Galerie Stadler, to serve as the invitation for his solo exhibition there. (Will create many prints as exhibition announcements.)

1965
Collaborates with Joan Brossa on the illustrated book *Novel·la*, published by Sala Gaspar, Barcelona, with thirty-seven lithographs by Tàpies.

1966
Publishes *Nou variacions sobre tres gravats de 1947–48*, a series of intaglios executed in 1947–48, with Sala Gaspar, Barcelona.

1967
Through Jacques Dupin begins long association with Galerie Maeght, Paris.

First prints (lithographs) published by Maeght Éditeur, Paris. Collaborates on first of seven special issues of the periodical *Derrière le Miroir*, no. 168, published by Maeght Éditeur, Paris, on the occasion of his exhibition there. Includes texts by Jacques Dupin and by art critic and theorist Michel Tapié and seven lithographs by Tàpies.

Exhibits in Ljubljana, Yugoslavia, "Seventh International Biennale of Graphic Art" (awarded First Prize); also 1969, 1971, 1973, 1981. [cat.]

Exhibits in Kunstmuseum, St. Gallen, Switzerland, "Antoni Tàpies: Das Gesamte Graphische Werk." [cat.]

1968
Collaborates on the periodical *Derrière le Miroir*, no. 175. Includes text by art critic Pierre Volboudt and eight lithographs by Tàpies.

Collaborates with Jacques Dupin on the illustrated book *La Nuit grandissante*, published by Erker-Verlag, St. Gallen, with twelve lithographs by Tàpies.

1969
Contributes a series of nine lithographs and one intaglio to accompany Joan Brossa's book *Fregoli*, published by Sala Gaspar, Barcelona.

Collaborates on the periodical *Derrière le Miroir*, no. 180. Includes text by Joan Brossa and one lithograph continuing on thirty pages.

Exhibits in Belgrade, Museum of Modern Art, "Antoni Tàpies / Jasper Johns: Litografijes." [cat.]

Exhibits in Kassel, Kasseler Kunstverein, "Antoni Tàpies: Das Gesamte Graphische Werk: Sammlung Dr. Friedrich und Maria-Pilar Herlt." [cat.]

1970
Collaborates with Joan Brossa on the illustrated book *Nocturn matinal*, published by Polígrafa, Barcelona, with seven lithographs by Tàpies.

1971
Collaborates with French poet André du Bouchet (b. 1924) on the illustrated book *Air*, published by Maeght, Paris, with sixteen lithographs, some with intaglio or collagraph.

1972
Creates the *Suite Catalana*, a series of five intaglios, published by Gustavo Gili, Barcelona.

Collaborates on the periodical *Derrière le Miroir*, no. 200. Includes text by Jacques Dupin and four lithographs by Tàpies.

Exhibits in Bradford (England), Bradford City Art Gallery and Museums, "Third British International Print Biennale"; also 1974 (awarded prize). [cat.]

1973
Collaborates with Catalan poet and critic Pere Gimferrer (b. 1945) and with Joan Brossa on the illustrated book *La clau del foc*, published by Polígrafa, Barcelona, with sixteen lithographs by Tàpies.

Collaborates with Brossa on *Poema* for the series *Placards* (lithographs with texts), published by Maeght Èditeur, Paris.

Collaborates with Brossa on the album *Poems from the Catalan*, published by Polígrafa, Barcelona, and Guinness Button, London, with twelve lithographs by Tàpies.

1974
Creates *Cartes per a la Teresa*, published by Maeght Éditeur, Paris, a series of sixty-four lithographs with collage, based on a 1971 series.

Collaborates on the periodical *Derrière le Miroir*, no. 210. Includes text by French art critic and literature professor Georges Raillard (b. 1927) and four lithographs by Tàpies.

Collaborates with German psychoanalyst and scholar Alexander Mitscherlich (1908–1982) on a lithograph with text for the series *Erker-Treffen 2*, published by Erker-Verlag, St. Gallen.

Collaborates with Joan Brossa on the album *Als mestres de Catalunya*, published by Sala Gaspar, Barcelona, with eight lithographs and one screenprint by Tàpies.

Collaborates with André du Bouchet on lithograph for the series *Placards* (lithographs with text), published by Maeght Éditeur, Paris.

Exhibits in Krakow, "Miedzynarodowe Biennale Grafiki;" also 1984. [cat.]

1975
Collaborates with French poet Jean Daive (b. 1941) on the illustrated book *X»*, published by Maeght Éditeur, Paris, with five mixed-media intaglios by Tàpies.

Collaborates with Japanese poet, art critic, and painter Shuzo Takiguchi (1903–1970) on the illustrated book *Llambrec material*, published by Polígrafa, Barcelona, with twelve lithographs by Tàpies.

Collaborates with the French poet Edmond Jabès (1912–1991) on the illustrated book *Ca Suit son cours*, published by Fata Morgana, Montpellier, with five intaglios by Tàpies.

Collaborates with the Cuban poet Carlos Franqui (b. 1921) on *Poemas para mirar* (lithograph with text), published by Editart, O. Blanco, Geneva.

Collaborates with Joan Brossa on *Naufragi al Nil* (screenprint with text), published by La Mulassa, Sala d'Art, Barcelona.

1976

Collaborates with Joan Brossa on the portfolio *Oda a Lluís Maria Xirinacs*, published by Comissio Lluís Maria Xirinacs, Barcelona, with lithographic cover and one lithograph by Tàpies.

Collaborates with Alexander Mitscherlich on the illustrated book *Sinnieren über Schmutz*, published by Erker-Verlag, St. Gallen, in 1978, with ten lithographs by Tàpies.

Collaborates with Carlos Franqui on *Libertad* (lithograph with text), published by Editart O. Blanco, Geneva.

Creates *Negre i roig*, published by Polígrafa, Barcelona, a series of fifteen intaglios, some incorporating flocking, collagraph, and carborundum.

With printer Joan Barbarà of Barcelona, creates over fifty intaglios, published by Galería Maeght, Barcelona.

1977

Collaborates with Spanish poet and playwright Rafael Alberti (b. 1902) on the illustrated book *Retornos de lo vivo lejano*, published by R.M., Barcelona, with fifteen lithographs by Tàpies.

1978

Collaborates with Mexican poet, critic, and essayist Octavio Paz (b. 1914) on the illustrated book *Petrificada petrificante*, published by Maeght Éditeur, Paris, with eight intaglios by Tàpies.

Exhibits in New York, Hastings Gallery, The Spanish Institute, "Antoni Tàpies: Selected Original Etchings and Lithographs 1947–1977." [brochure]

1979

Collaborates with Joan Brossa in the publication of a book, *U no és ningú*, with accompanying set of twelve intaglios and two lithographs, published by Polígrafa, Barcelona.

Collaborates with Swiss playwright and author Max Frisch (1911–1991) on a lithograph with text for the series *Erker-Treffen 3*, published by Erker-Verlag, St. Gallen.

Collaborates on the periodical *Derrière le Miroir*, no. 234. Includes text by Argentinean novelist Julio Cortázar (1914–1984) and two lithographs by Tàpies.

1980

Collaborates with Spanish poet Jorge Guillen (1893–1984) on the illustrated book *Repertorio de junio*, published by Ediciones Carmen Durango, Valladolid, Spain, with six intaglios by Tàpies.

Creates *Suite 63 x 90*, published by Erker-Verlag, St. Gallen, a series of ten lithographs.

Exhibits in Amsterdam, Stedelijk Museum, "Antoni Tàpies: Paintings and Graphics 1950–1980." [cat.]

1981

Delivers a speech entitled "The Poet J. V. Foix and Painting" for the award to the poet of The Gold Medal of the Autonomous Government of Catalonia.

Collaborates with French poet Yves Bonnefoy (b. 1923) on the portfolio *La Pierre trouant le sens mais, plus tard, le ciel au fond de l'entaille*, published by Editions F. B. (François Benichou), Paris, with three intaglios by Tàpies.

Collaborates with Jean Daive on the illustrated book *Tàpies, répliquer*, published by Maeght S.A., Paris, with four mixed-media intaglios by Tàpies.

Collaborates with the Spanish poet and critic José Miguel Ullan (b. 1944) on illustrated book *Anular*, published by R. L. D. (Robert and Lydia Dutrou), Paris, with twenty-two mixed-media intaglios by Tàpies.

Exhibits in Baden-Baden, Germany, "2nd Biennial of European Graphic Art." [cat.]

1982

Designs the set for Jacques Dupin's play *L'Eboulement*, performed in Paris.

Collaborates with the Spanish poet José Angel Valente (b. 1929) on the illustrated book *El péndulo inmóvil*, published by Editart-D. Blanco, Geneva, with intaglios by Tàpies.

Collaborates on the periodical *Derrière le Miroir*, no. 253. Includes texts by Jacques Dupin and Georges Raillard and one lithograph by Tàpies.

Collaborates with Pere Gimferrer on the illustrated book *Aparicions*, published by Polígrafa, Barcelona, with nine intaglios by Tàpies.

1983

Contributes a frontispiece (intaglio) to Jacques Dupin's *Der Bergpfad: Le Sentier de montagne*, published by Ed. Edition M., Hannover.

Contributes a frontispiece (intaglio) to the French poet André Frénaud's (b. 1907) *La Nourriture du bourreau*, published by Thierry Bouchard/Gaston Puel, Losne (France).

Exhibits in Barcelona, Fundació Joan Miró, "Tàpies: Cartells" (and tour). [cat.]

1984

Collaborates with Edmond Jabès on the illustrated book *Dans la Double Dépendance du dit*, published by Bruno Roy (Fata Morgana), Montpellier, with three intaglios by Tàpies.

Collaborates with J. V. Foix, on the illustrated book *L'Estació*, published by Carles Taché, Barcelona, with five intaglios by Tàpies.

Collaborates with Yves Bonnefoy on the portfolio *Un Fragment de statue dans L'herbe d'un enclos encore desert*, published by Editions F. B. (François Benichou), Paris, with three intaglios by Tàpies.

Creates *Variations*, published by Erker-Verlag, St. Gallen, a series of eleven lithographs.

1985

Collaborates with Joan Brossa on the portfolio *El Rei de la Màgia*, published by Edicions Tristany, Barcelona, with three intaglios by Tàpies.

Contributes frontispiece (intaglio) to André du Bouchet's, *Sur un gerondif*, published by Editions L'Ire des Vents, Paris.

Contributes frontispiece (intaglio) to José Angel Valente's *Trois Leçons de ténèbres* published by Editions Unes, Le Muy (France).

Creates the illustrated book *Llull-Tàpies*, published by Taché, Barcelona, and Lelong, Paris, with twenty-five mixed-media intaglios by Tàpies and contributions from Llull specialist Miquel Batllori and Pere Gimferrer.

Collaborates with Joan Brossa on the portfolio *Sextina en el Museu de Joguets de Figueres*, published by Edicions Tristany, Barcelona, with three intaglios by Tàpies.

Creates *Roig i negre*, published by Polígrafa, Barcelona, a series of five intaglios with carborundum.

Exhibits in Grenchen, Switzerland, "International Triennial of Original Graphic Prints (awarded prize). [cat.]

Exhibits in Valencia, Spain, Centre Municipal de Cultura, "Antoni Tàpies: Gravats." [cat.]

1986

Contributes frontispiece (intaglio) to José Angel Valente's *Material Memoria*, published by Editions Unes, Le Muy (France).

1987

Collaborates with French poet and critic Jean Frémon (b. 1946) on the illustrated book *Equation*, published by Daniel Lelong, Paris, with five intaglios by Tàpies.

Contributes a frontispiece (intaglio) to J. V. Foix's *XL Sonnets* published by Associació de Bibliòfils, Barcelona.

Contributes frontispiece (intaglio) to José Angel Valente's *L'Eclat* and *Intérieur avec figures*, both published by Editions Unes, Le Muy, France.

Creates *Variations sur un thème musical* (*Variations on a Musical Theme*), published by Lelong, Paris. A series of twenty lithographs with collagraph, it was printed with Damià Caus at Litografías Artísticas, Barcelona.

1988

Collaborates with Yves Bonnefoy on the portfolio *Un Vase de terre crue et le T du nom de Tàpies*, published by Editions F. B. (François Benichou), Paris, with three intaglios by Tàpies.

Creates a series of eleven large-format intaglios measuring up to 6 1/2 feet square, published by Edicions T, Barcelona and printed with Joan Barbarà, Barcelona.

Creates *Erinnerungen*, published by Erker-Verlag, St. Gallen, a series of five lithographs done in conjunction with the German edition of his autobiography, *Errinnerungen: Fragment einer Autobiographie*, published by Erker-Verlag.

Exhibits in Portland, Maine, The Baxter Gallery, Portland School of Art, "Antoni Tàpies: Graphic Work 1947–1987." [tour; cat.]

Exhibits in Vilabertran, Spain, Canònica de Santa Maria, "Gravats." [cat.]

Exhibits in Wolfenbüttel, Germany, Herzog August Bibliothek Wolfenbüttel, "Antoni Tàpies: Die Bildzeichen und das Buch." [cat.]

Collaborates with Joan Brossa on the illustrated book *Carrer de Wagner*, published by Edicions T, Barcelona, with ten intaglios by Tàpies.

1989

Creates illustrated book *Art and Spirituality*, published by Edicions T, Barcelona, with text and two intaglios by Tàpies.

Exhibits in Peking, Palau de Belles Arts, "Tàpies: Prints." [cat.]

1990

Collaborates with Spanish philosopher and scholar María Zambrano (b. 1904) on the illustrated book *El árbol de la vida: La Sierpe*, published by Ediciones T, Barcelona, with three intaglios by Tàpies.

Creates thirty intaglios, several of monumental proportions, published by Edicions T, Barcelona and printed with Barcelona printers Joan Roma and Takeshi Motomiya at Taller Nou, Barcelona.

Exhibits in Asturias, Spain, Caja de Ahorros de Asturias, "Tàpies: Escultura/Aguafuertes." [tour; cat.]

1991

Collaborates with Jacques Dupin on the illustrated book *Matière du souffle*, published by Edicions T, Barcelona and Galerie Lelong, Paris, with thirteen intaglios by Tàpies. [forthcoming]

Collaborates with Jean Frémon on the illustrated book *Tàpies, la substance et les accidents*, published by Editions Unes, Le Muy, France, with fifteen lithographs by Tàpies. [forthcoming]

Bibliography

*Works in English, or with English summaries, marked with asterisks.

Spain, and International Art of the Period

BOOKS

Calvo Serraller, Francisco. *España: Medio siglo de arte de vanguardia, 1939–1985*, 2 vols. Madrid: Fundacion Santillana and Ministerio de Cultura, 1985.

*Dyckes, William, ed. *Contemporary Spanish Art*. New York: The Art Digest, Inc., 1975.

*Hooper, John. *The Spaniards: A Portrait of the New Spain*. Revised ed., London: Penguin Books, 1987.

*Leymarie, Jean, et al. *Art Since Mid-Century: The New Internationalism*, vol. 1, *Abstract Art*. Greenwich, Conn.: New York Graphic Society, 1971.

EXHIBITION CATALOGS

*Barcelona, Fundació Caixa de Pensions. *L'art Espanyol en la col·lecció de la Fundació Caixa de Pensions*. Barcelona: Fundació Caixa de Pensions, 1987.

*Barcelona, Palau Robert. *Barcelona/Paris/New York: El camí de dotze artistes Catalans, 1960–1980*. Barcelona: Generalitat de Catalunya, Departament de Cultura, 1985.

Berlin, Staatliche Kunsthalle. *Art i Modernitat als Països Catalans: Katalanische Kunst des 20. Jahrhunderts*. Berlin: Staatliche Kunsthalle, 1978.

*Dordogne, Château de Biron. *Le Défi Catalan de Picasso et Miró à la nouvelle génération*. Dordogne: Château de Biron, 1988.

*London, Hayward Gallery. *Homage to Barcelona: The City and its Art, 1888–1936*. London: Arts Council of Great Britain, 1985.

Madrid, Fundación Caja de Pensiones. *Pintura Española: Aspectos de una decada, 1955–1965*. Madrid: Fundación Caja de Pensiones, 1988.

Madrid, Fundación Juan March. *Museo de Abstracto Arte Español: Cuenca*. Madrid: Fundación Juan March, 1988.

*Milan, Comune de Milano. *Espagna: Artisti Spagnoli contemporanei*. Milan: Comune de Milano, 1988.

Paris, Musée d'Art Moderne de la Ville de Paris. *Cinq Siècles d'art Spagnol: Le siècle de Picasso*. Madrid: Ministry of Culture, 1987.

*Venice, La Biennale di Venezia. *Spain: Artistic Avant-garde and Social Reality, 1936–1976*. Venice: La Biennale de Venezia, 1976.

Tàpies

Major references since 1985 are cited. Complete bibliographies can be found in Manuel Jose Borja(-Villel), 1989, and in Anna Agustí, 1988 and 1990.

BOOKS

*Agustí, Anna. *Tàpies: The Complete Works, Volume 1: 1943–1960*. New York: Rizzoli, 1988.

*Agustí, Anna. *Tàpies: The Complete Works, Volume 2: 1961–1968*. New York: Rizzoli, 1990.

*Bonito Oliva, Achille. *Antoni Tàpies: Osservatore/partecipante, dipinti e sculture*. Rome: Cleto Polcina Edizioni, 1988.

*Borja(-Villel), Manuel J(ose). *Antoni Tàpies: The "Matter Paintings,"* vols. 1 and 2. Ann Arbor, Mich.: University Microfilms International, 1989.

*Borja-Villel, Manuel J. *Fundació Antoni Tàpies*. Barcelona: Fundació Antoni Tàpies, 1990.

Catoir, Barbara. *Gespräche mit Antoni Tàpies*. Munich: Prestel-Verlag, 1987.

*Combalía Dexeus, Victòria. *Tàpies*. New York: Rizzoli International Publications, 1990.

*Permanyer, Lluís. *Tàpies and the New Culture*. New York: Rizzoli, 1986.

Tàpies, Antoni. *Selected Essays*. Eindhoven: Van Abbe Museum, 1986.

EXHIBITION CATALOGS

*Barcelona, Ajuntament de Barcelona. *Tàpies: els anys 80*. Barcelona: Ajuntament de Barcelona, 1988.

*Bayreuth (Germany), Kunstverein Bayreuth. *Antoni Tàpies: Arbeiten 1947–1988*. Mainz: Dorothea Van Der Koelen Verlag, 1990.

Brussels, Musée d'Art Moderne. *Tàpies: Europalia 85, España*. Brussels: Musée d'Art Moderne, 1985.

Düsseldorf, Kunstsammlung Nordrhein-Westfalen. *Tàpies: Die Achtziger Jahre, Bilder, Skulpturen, Zeichnungen*. Düsseldorf: Kunstsammlung Nordrhein-Westfalen, 1989.

Milan, Palazzo Reale. *Tàpies-Milano: Dipinti, sculture, opere su carta grafiche*. Milan: Palazzo Reale, 1985.

Prints and Illustrated Books

GENERAL REFERENCES CITING TÀPIES

BOOKS

Bellini, Paolo. *Histoire de gravure moderne*. Paris: Chez Jean de Bonnot, 1979.

*Castleman, Riva. *Contemporary Prints*. New York: Viking Press, 1973.

*Castleman, Riva. *Prints of the Twentieth Century: A History*. New York: The Museum of Modern Art, 1976.

Chapon, François. *Le Peintre et le livre: L'Age d'or du livre illustré en France, 1870–1970*. Paris: Flammarion, 1987.

*Dyckes, William, ed. *Contemporary Spanish Art*. New York: The Art Digest, Inc., 1975 (chapter on "Graphics in Spain," by Robert John Fletcher).

Gallego Gallego, Antonio. *Historia del grabado en España*. Madrid: Ediciones Càtedra, S.A., 1979.

*Melot, Michael. *Prints*. Geneva: Editions d'Art Albert Skira S.A., 1981.

*Siblik, Jiri. *Twentieth-Century Prints*. London and New York: Hamlyn, (c. 1970).

*Stubbe, Wolfe. *Graphic Arts in the Twentieth Century*. New York/London: Frederick A. Praeger, 1963.

Wember, Paul. *Blattkünste: Internationale Druckgraphik seit 1945*. Krefeld: Scherpe Verlag, 1973

EXHIBITION CATALOGS

Barcelona, Centre Cultural de la Caixa de Pensions. *El gravat de creació: calcografia contemporània a Catalunya*. Barcelona: Fundació Caixa de Pensions, 1983.

Berlin, Kupferstichkabinett, Staatliche Museen, Preussischer Kulturbesitz. *Druckgraphik: Wandlungen eines Mediums seit 1945*. Berlin: Kupferstichkabinett, Staatliche Museen, Preussischer Kulturbesitz, 1981.

*Canberra, Australian National Gallery. *The Spontaneous Gesture: Prints and Books of the Abstract Expressionist Era*. Canberra: Australian National Gallery, 1987.

Hagen (Germany), Karl Ernst Osthaus Museum. *Als Beispiel Erker: Galerie Verlag Presse*. Hagen: Karl Ernst Osthaus Museum, 1980.

Hannover, Kestner-Gesellschaft. *Das Buch Des Künstlers*. Hannover: Kestner-Gesellschaft, 1989.

*Lexington, University of Kentucky. *Graphics 74: Spain*. Lexington: University of Kentucky, 1974.

*London, Redfern Gallery. *Ediciones Polígrafa*. London: Redfern Gallery, 1979.

*London, Victoria and Albert Museum. *From Manet to Hockney: Modern Artists' Illustrated Books*. London: Victoria and Albert Museum, 1985.

*Madrid, Grupo Quince. *Contemporary Spanish Prints*. Madrid: Grupo Quince, 1979.

Madrid, Museo Municipal de Madrid. *Técnicas tradicionales de estampación 1900–1980*. Madrid: Ayuntamiento de Madrid, Delegacion de Cultura, 1981.

Munich, Staatliche Graphische Sammlung. *Das Informel in der Europäischen Druckgraphik: Sammlung Prelinger*. Munich: Staatliche Graphische Sammlung, 1985.

*New York, Independent Curators Incorporated. *Contemporary Illustrated Books: Word and Image, 1967–1988*. New York: Independent Curators Incorporated, 1989.

*New York, The Museum of Modern Art. *Contemporary Painters and Sculptors as Printmakers*. New York: The Museum of Modern Art, The International Council, 1966.

*New York, The Museum of Modern Art. *Modern Art in Prints*. New York: The Museum of Modern Art, The International Council, 1973.

*New York, The Museum of Modern Art. *Printed Art: A View of Two Decades*. New York: The Museum of Modern Art, 1980.

Nürnberg, Kunsthalle. *Graphik der Welt: Internationale Druckgraphik der Letzten 25 Jahre*. St. Gallen: Erker-Verlag and Nürnberg: Kunsthalle, 1971.

Paris, Bibliothèque Nationale. *Le Livre et l'artiste: Tendances du livre illustré francais, 1967–1976*. Paris: Bibliothèque Nationale, 1977.

Paris, Bibliothèque Nationale. *50 Livres illustrés depuis 1947*. Paris: Bibliothèque Nationale, 1988.

Saint-Paul de Vence, Fondation Maeght. *L'Univers d'Aimé et Marguerite Maeght*. Saint-Paul de Vence: Fondation Maeght, 1982.

Venice, La Biennale de Venezia. *Aspetti della grafica Europea*. Venice: La Biennale di Venezia, 1971.

REFERENCES ON TÀPIES

BOOKS

Catoir, Barbara. *Gespräche mit Antoni Tàpies*. Munich: Prestel-Verlag, 1987 (chapters on: "Film-Poesie-Literatur," and "Serie, Variation, Graphik").

Fernandez-Braso, Miguel. *Conversaciones con Tàpies*. Madrid: Ediciones Rayuela, 1981 (chapters on "Literatura/Brossa," "Libros con Poetas," "Obra Grafica").

*Galfetti, Mariuccia. *Tàpies: Obra gràfica/Graphic Work 1947–1972*. Barcelona: Editorial Gustavo Gili, S.A., 1973.

*Galfetti, Mariuccia. *Tàpies: Obra gràfica/Graphic Work 1973–1978*. Barcelona: Editorial Gustavo Gili, 1980.

Malet, Rosa Maria, and Miquel Tàpies. *Els cartells de Tàpies*. Barcelona: Ediciones Polígrafa, 1984.

EXHIBITION CATALOGS

Indicated after exhibition entries in Chronology.

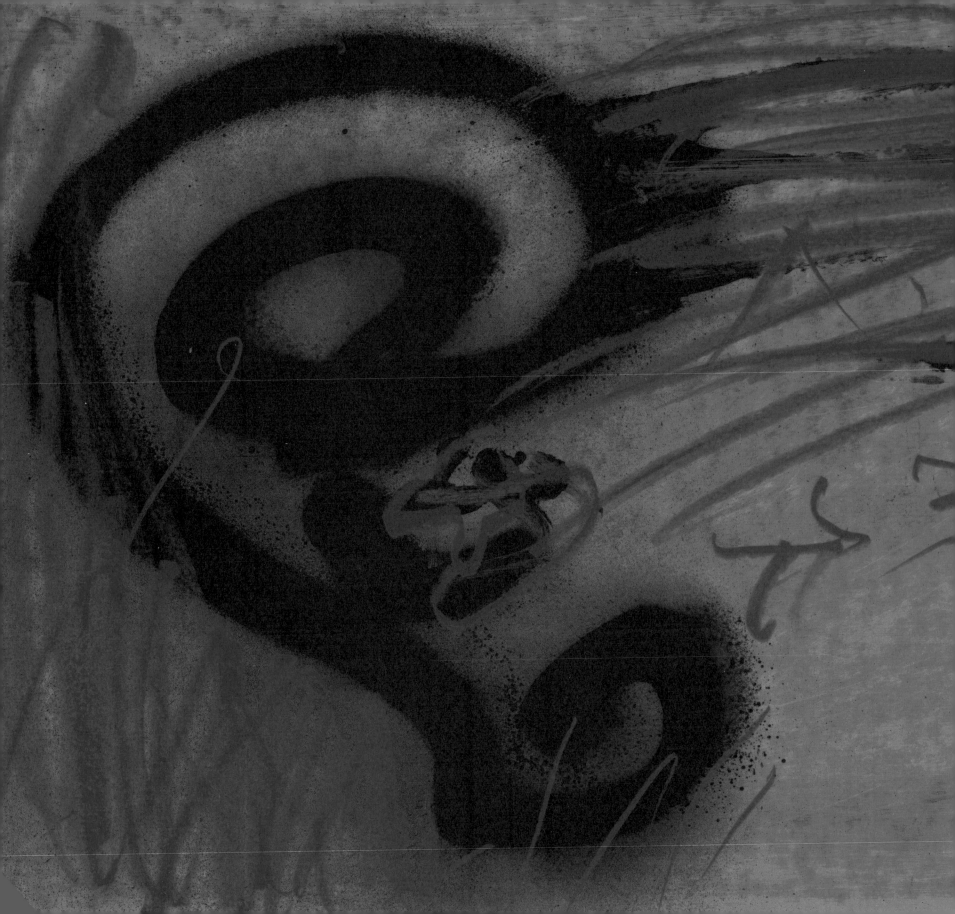